# HENLEY-ON-THAMES
## THROUGH TIME
Elizabeth Hazeldine

*Elizabeth. J. Hazeldine*

AMBERLEY PUBLISHING

# Acknowledgements

I would particularly like to thank Ann Cottingham, as her excellent book *The Hostelries of Henley* was an essential point of reference. I am grateful for the publications *The Victorian County History of Henley-on-Thames* and *Burns History of Henley*, both of which, on many occasions, pointed me in the right direction.

Richard Wilson, thank you for allowing me access to your marvellous treasure trove of documents and pictures. My thanks go to Henley Fire Brigade for the images of fire fighters past, and Brakspears for coming up trumps when asked for photographs of Henley's public houses. I am also grateful to Thames Valley Police Museum for allowing me to use the image of Henley Police Station, and to Norman Topsom, who provided the railway images and Stuart Turners for archive photographs.

I am grateful to my sister Melanie, who patiently listened as I ran ideas past her. Thanks are also due to Alison, who volunteered to read through drafts and gave valuable advice.

I wanted *Henley-on-Thames Through Time* to touch on the lives of those who lived and worked in the town, and faced challenges and adversities that we in our time cannot fully comprehend. To all of those individuals, and the many residents and locally based companies who offered assistance, this book is dedicated.

First published 2014

Amberley Publishing
The Hill, Stroud, Gloucestershire, GL5 4EP
www.amberley-books.com

Copyright © Elizabeth Hazeldine, 2014

The right of Elizabeth Hazeldine to be identified as the Author of this work has been asserted in accordance with the Copyrights, Designs and Patents Act 1988.

ISBN  978 1 4456 3812 6 (print)
ISBN  978 1 4456 3829 4 (ebook)

British Library Cataloguing in Publication Data.
A catalogue record for this book is available from the British Library.

Typesetting by Amberley Publishing.
Printed in Great Britain.

# Introduction

Henley's fortunes were very much built upon its links with the river trade, with the running of barges on the Thames that primarily served London. In 1274, during the reign of Edward I, an order was ratified to widen the Thames for the benefit of barge trade, as the size and weight of commercial barges had been causing problems in relation to the depth of the river. Two Bridgemen were chosen annually by the Corporation of Henley, linked to the upkeep of the Church of St Mary's and Henley Bridge and administration of property left to the town. They also acted as Church Wardens. Tolls were gathered to be used to repair and maintain the bridge at Henley, collected as bargemen passed under said bridge. Things did not always run smoothly. The Lord Mayor and Alderman of London complained about the town's water carriage charges being increased artificially on occasion, and in 1596 the City of London's Alderman demanded that corn held at Henley should be released to relieve the hunger of the people of London.

Henley's riverside location between London and Oxford gave it a prominent role in the Civil War, particularly from 1642 when Oxford became the Royalist capital while London remained with Parliament. The Henley Corporation complained about the passing through of barges and unloading of river craft at Henley. The barges carried arms and soldiers, both of which were often sent on to neighbouring towns.

Towards the end of the 1600s, Henley's location on the roads to and from London meant that it was by now an established coaching stop, a fact that added considerably to its fortunes with the growth of specialised coaching inns and enhanced business opportunities for the local populace. In the closing decades of the nineteenth century, Henley-on-Thames was in the process of reassessment, since the financial fortunes of the market town were built by its connection to river trade, which had fortified the area for well over 500 years. The arrival of the railways and building of canals had necessitated the rethinking of Henley's future, and the use of the invaluable Thames as a draw for the wealthy, who were turning to the open waters as a leisure activity and escape from city life. The Great Western Railway, which ran from Henley to Twyford and opened in June 1857, brought visitors to the town in increasingly large numbers, especially at Henley's Royal Regatta (begun in 1839), when it was not unknown for over 30,000 to converge on the town.

Weekenders could unwind on coach excursions into the countryside, with many small companies in the town providing day trips. The Kellys Directory of 1891 described Henley-on-Thames as, 'The prettiest summer retreat in the county, surrounded by handsome villas and plantations, a very favourite and fashionable place to resort'.

In the 1890s, this small market town contained complicated and wide-reaching contrasts, the wealthy leading privileged lives in fine town houses, and the landed gentry residing at their

country estates. The less affluent of the town's population crowded into small terraced houses, many turning to Henley's workhouse in times of dire need. The working classes were employed in building, brewing, retail and traditional crafts, many with large families to support.

Things gradually began to improve as education for less fortunate children expanded: a school funded by public subscription opened on Gravel Hill, as well as a separate National Infant School, which stood on Greys Hill. The recently closed Kenton Theatre in New Street was the location of the National School from 1817, before the building was used as St Mary's Hall. The British School situated on the Reading Road had capacity by the 1870s for 153 pupils, and the Grammar School was situated at the former Bell Inn, Northfield End.

General health improvements were aided by the establishment of the Henley Waterworks, run as a private company and opened in the June of 1882 by the Honourable W. H. Smith. Water sourced from a well was brought to the surface at the Pumping Station (which still stands) at the bottom end of Deanfield, and the supply of water was stored in a reservoir. 1834 saw the introduction of gas lighting, the Gas Companies Works situated in Greys Lane.

Sporting pastimes began to grow increasingly popular, with the Lawn & Tennis Club established in 1880, Henley Cricket Club in existence by 1850, and a Football Club launched in 1871.

Henley-on-Thames is today a vibrant market town, with a wide spectrum of established commercial, social, cultural and sporting activities. Its historical architecture and the River Thames are very much at the heart of Henley's beauty.

### William Thackara Hairdresser, Market Place

The three-storey building, which dominates the corner of Duke Street and Market Place, dates from the early nineteenth century. With a later stucco façade , the shop front was customised in the twentieth century. By 1851, James Thackara had set up as a hairdresser at the corner plot. After his death in 1874, his widow, Ruth, stayed in Market Place and ran a stationery shop. By 1891, Ruth had retired and relocated to Bell Street, able to live on her own means. James and Ruth's son, William Thackara, and his wife Mary, took on No. 1 Market Place. William ran the same trade as his father, and described himself as 'an artist in hair', aided by hairdresser's assistant John Prince. He also continued with his mother's stationery business. By 1901, No. 1 Market Place was occupied by sugar confectioner William Taylor. By 1911, Taylor had relocated his business to No. 28 Duke Street, his former premises now a branch of Joules Clothing.

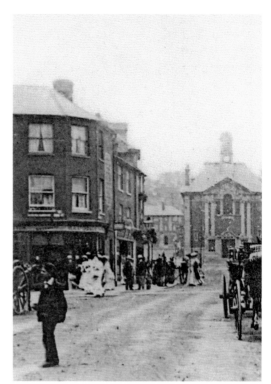

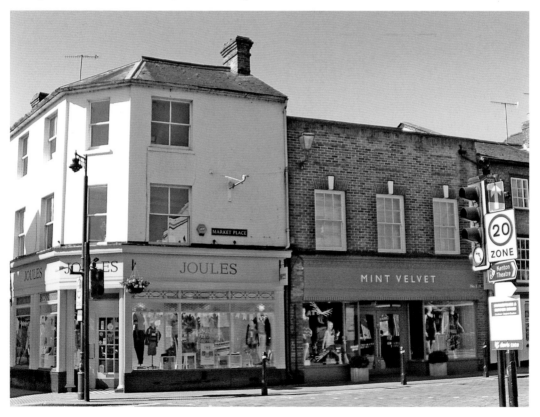

**Charles Monk, Draper, & Sidney Higgins, Bookseller, Market Place & Hart Street Corner**

Charles Monk began as a tailor's apprentice to George Young of Bell Street. He went on to own his own drapery and outfitter's business at No. 2 Market Place. By 1911, Charles had been widowed and thus his children assisted in the business. Henry was his father's partner and Katherine kept the company books. Charles Monk died in 1920, and Henry continued the business well into the twentieth century; the 1942 Kelly's Directory listing indicated that the company had, by then, expanded into Nos 1 & 3 Bell Street, the area known as Monks Corner. The Monks' former business premises are now occupied by Starbucks Coffee. Previous to Timothy Whites, the occupier of the building at the corner of Hart Street and Bell Street was Mr Sidney Higgins, stationer and bookseller, and agent for the Society for Promoting Christian Knowledge. By 1911, Higgins had relocated his business to Slough, and his former Henley shop is now a branch of Monsoon.

**The Feathers Hotel, Market Place, _c._ 1900s**
Directly next door to the Oxford Temperance Hotel stood the Feathers Hotel, which catered for those who preferred a stronger tipple. The image clearly shows its projecting street lamp. It had originally stood in Middle Row, but closed in 1796, later to be demolished, and was reopened at No. 4 Market Place. Alfred Holbrow relocated to Henley with his wife Emily Annie, and from 1894 was the Feathers' Landlord. The couple quit the Feathers in 1904, and moved a short distance to No. 64 Kings Road. Alfred reverted back to his original profession of architect. The Feathers was closed down by order of the Licensing Magistrate in December 1908, and was later demolished. A dairy was built in its place, and that building is now occupied by Patisserie Valerie. Homage to its predecessor is the feather emblem, situated high up on the front of the premises.

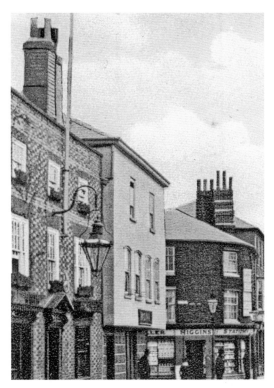

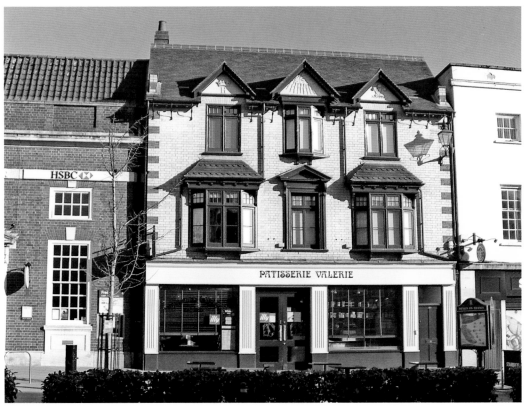

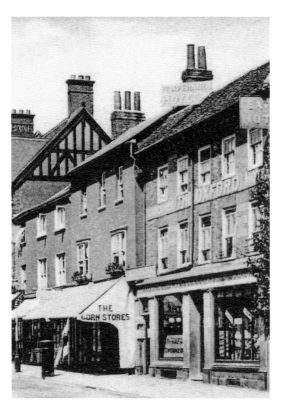

### Oxford Temperance Hotel, Market Place, 1890s

In 1882, the Henley Coffee Tavern established a Temperance Hotel at Nos 6–8 Market Place. The Manager was Alfred John Adams, who had diversified from his profession of coach painter, working out of Duke Street. Although married to Ellen, Alfred seems to have run the hotel with the assistance of his sister, Clara. The hotel had five guest bedrooms, with the addition of stabling for four horses. It is possibly a reflection on the success of an establishment that shunned intoxicating substances, that by the early twentieth century, Adams was again working as a coach painter, situated in Reading, Berkshire. The Oxford Temperance Hotel was auctioned off at the Catherine Wheel on 20 May 1922, its site now occupied by a branch of HSBC Bank.

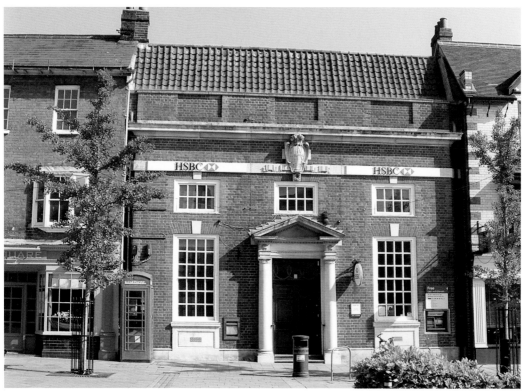

### Remenham Dairy, Market Place

Thomas Atkins worked as a dairyman out of Market Place. By 1911, he had relocated from the premises pictured (his projecting business sign clearly visible) to No. 4 Market Place, a rebuild on the site of the former Feathers Hotel. Originally a Putney man, he married a local girl, Martha Ann, born in Nuffield 1853 and a year her husband's junior. It was very much a family affair, with the couple's children, Harriet and Frederick (also employed as a coach painter) assisting. The business, it would seem, brought its financial rewards, with Thomas ending his days at No. 30 St Marks Road, on 21 September 1938. He left his son Frederick Henry Atkins, by now Sub Postmaster, a share of £5,677. This quaint little building is regrettably long since demolished and the site now occupied by a branch of Cargo.

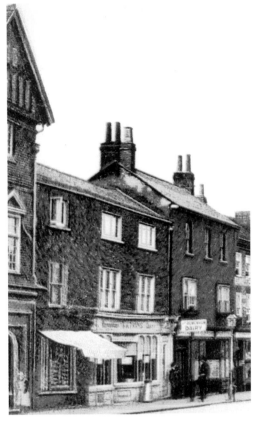

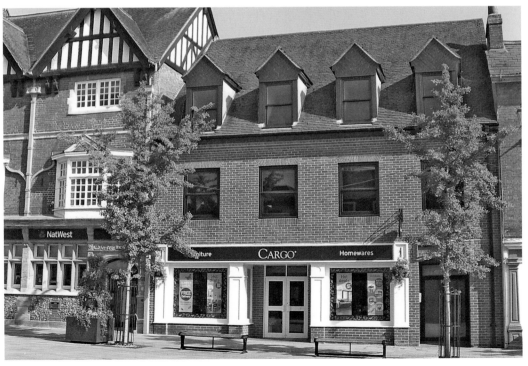

## The Argyll & Hatton Drapers, Market Place

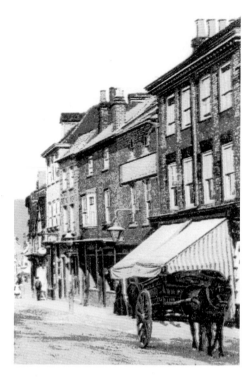

The Argyll was initially known as the Cannon (this name later used for a hostelry in Upper Market Place), then The Hop Leaf. In 1887 it was renamed The Argyll Hotel. From 1899, Henry Norman was appointed Landlord of the Argyll, assisted by his second wife, Elizabeth. The Normans left the Argyll in 1905, and Henry died in Wokingham the following year. The Argyll is still open, its appearance much altered by the 1919 mock-Tudor frontage, though parts of the earlier build survive. John Hatton (born 1829 in Chidrey) ran a draper's in Wantage Market Place, and by the 1870s employed five men. In the 1880s he had relocated to Henley, and John was still in business well into his seventies as Hatton Draper Outfitters at No. 27 Market Place. He was assisted by his wife, Emma, and children Frank and Ada. Hatton's former shop is at present unoccupied.

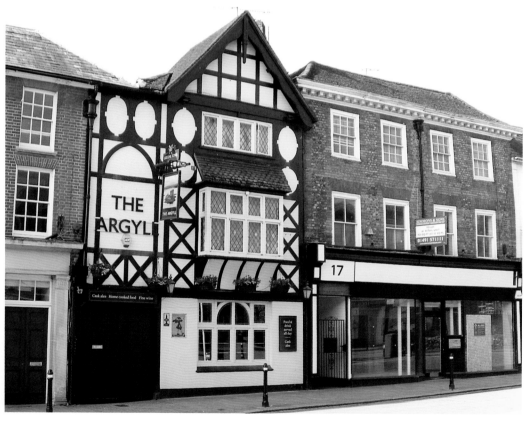

## Facy Brothers, Market Place, *c.* 1896

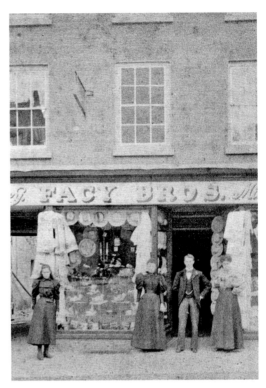

In 1896, three brothers, Samuel, Thomas and John, left the family farm to make a living in the clothing trade. The eldest, Sam, set his sights on Abingdon and traded as a general draper. Tom and John Facy took the lease on the former outlet of William Hamilton in Market Place, a building with some age that was concealed beneath an eighteenth-century façade. The two men opened as general draper's, but shortly after Tom decided to try his luck in London, and opened a shop at Hither Green. John and his wife, Alice Maude, stayed on in Henley. Following the end of the First World War, John brought the buildings on either side in order to increase the business's departments. After John's death in 1951, his sons John and Bernard, both experienced drapers, carried the business forward. The initial location of the draper's is now occupied by Feather & Black, while Facy is now staffed by the fifth generation of the family, and is situated directly next door.

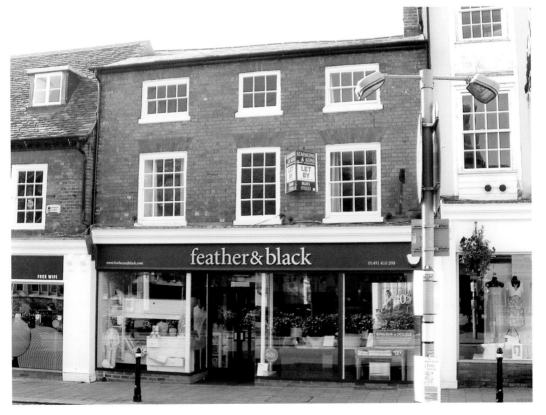

## Henley Police Station, Market Place

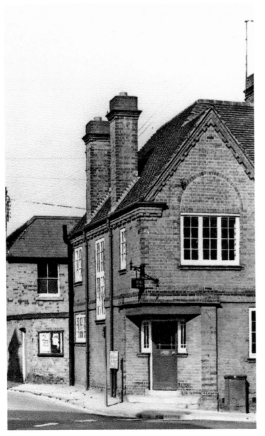

In 1835, Henley had to manage with just six constables. In 1856, the County Constabulary was formed, and in 1868, two houses that stood at the bottom end of West Street were purchased. The properties were extensively altered to the plans of William Wilkinson and Henley had its new police station. In 1881, Thomas Jennings was a Private Constable, living in Church Street, Bicester. He moved swiftly through the ranks, and by the 1890s, Thomas was Woodstock Station's Inspector. By the 1990s, Jennings relocated to Henley, accompanied by his wife Louisa and their three children. Assisted by two Sergeants and fifteen Constables, much of Jennings's time seems to have been taken up with various flare-ups in the town's numerous drinking establishments. His responsibilities also included that of Inspector under the Cattle Contagious Diseases Acts and the Food, Drugs and Explosives Act. Thomas Jennings subsequently moved to Banbury, and Henley's Police Station was relocated in 2004. Its former site is now the location of The Henley Brew House.

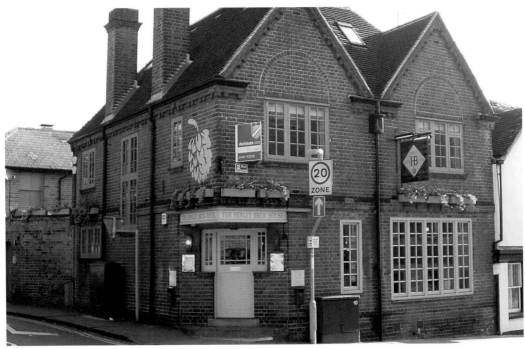

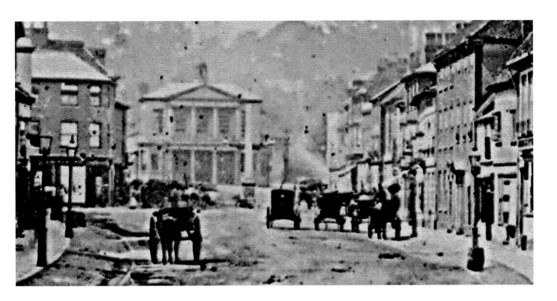

**Georgian Town Hall, Market Place**

By 1794, most of the High Street's Middle Row, which included the Guildhall, had been cleared. After much discussion, the Corporation decided to build a replacement Town Hall on the site of a recently demolished market house. The architect and builder was Henley man William Bradshaw, and in the December of 1796 the Town Hall was completed. Neoclassical in style, the structure included a pediment, portico, Doric columns and a balcony. The ground level had an open colonnade, which served as a Corn Exchange. In 1870, the open colonnaded area was filled in to provide more office space. The Corn Exchange was thus relocated indoors, alongside an entertainment room. A clock was later added to the Town Hall's frontage. By the 1890s, it was felt that Henley's Georgian Town Hall had become somewhat dilapidated, and the Corporation decided to build a replacement. The consensus was that a rebuilt Town Hall would be a way for Henley to mark Queen Victoria's Diamond Jubilee of 1897. When the building was demolished in 1898, the porticos, balcony and windows were purchased by Henley builder Councillor Charles Clements, who incorporated them in the construction of his new home at Crazies Hill (*pictured*), which stands to this day.

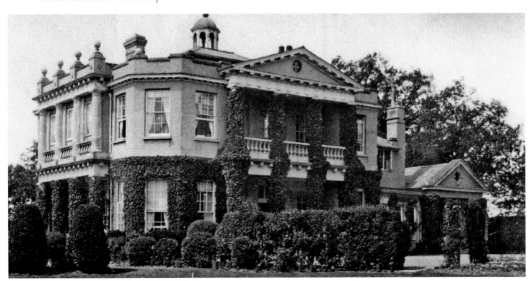

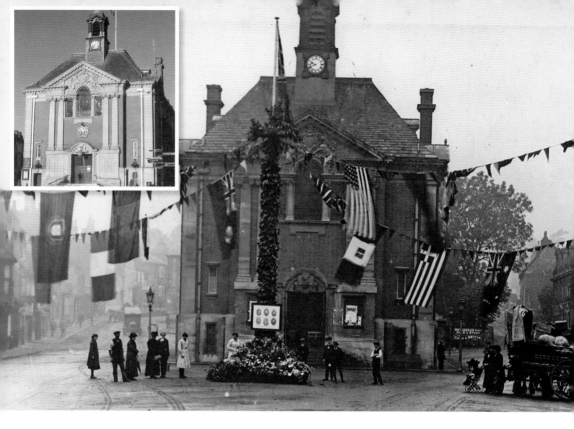

**Town Hall, Market Place, Photographed on Nelson Day, 1918**

Architect Henry Thomas Hare, who had designed Oxford's recently completed Town Hall, was granted the contract to build another Town Hall for Henley. A subscription system was set up to meet the £9,766 cost involved, and a further £1,895 was borrowed in order to purchase and demolish a further property. With a subsequent shortfall, the Corporation had to borrow a further £4,000. Completed in 1901, the Town Hall was constructed of red brick and Bath Stone, with the main Council Chambers on the ground floor. The Parlour Room was complimented by a large, marble chimney piece, which had been gifted by Frank Crisp of Friar Park. The Grand Hall was designed for use as a function room, with a plastered and barrel-vaulted ceiling. The principal staircase was set off by an impressive stained-glass window, produced by Henry George Alexander Holiday. It was ironic that the formal opening of Henley's Town Hall, which was not universally admired, was postponed until 13 March 1901 due to the death of Queen Victoria. Henry Ware died on 10 January 1921 at 'Egyptwood', Tarnham Common, in Buckinghamshire. He was buried at Golders Green Crematorium, and left his widow, Susan Maria Hare, £23,033 12s 10d. Nelson Day was celebrated annually on 21 October to mark the victory of Vice Admiral Horatio Nelson at the Battle of Trafalgar in 1805. The day was marked with parades and formal dinners, but after 1918 the tradition dwindled.

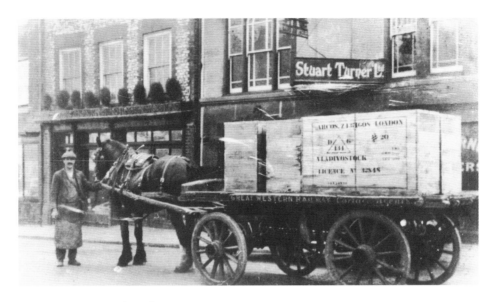

**Stuart Turners, Market Place, c. 1910s**

Sydney Marmaduke Stuart Turner (who was employed at Shiplake Court) initially ran a cottage industry, designing, building and selling model steam engines. In 1908, he founded a company, which he located at premises neighbouring the Broad Gates Inn in Market Place. In 1913, the company expanded its product range, winning a military competition to produce a generator to power a wireless plant. During the First World War, Sydney took on Broad Gates Inn and used it as an area to produce equipment for the war effort. Sydney Stuart Turner stepped down from his company in 1920; he departed on board the *Clan Mackinlay* steamer from Liverpool on 27 November, bound for Durban, South Africa. Stuart Turner's (formally known as Shiplake Works), which later built a new premises behind the former Broad Gates, is still very much part of Henley's commercial sector, and its initial location on Market Place is now occupied by Traveltime Independent Travel Agents.

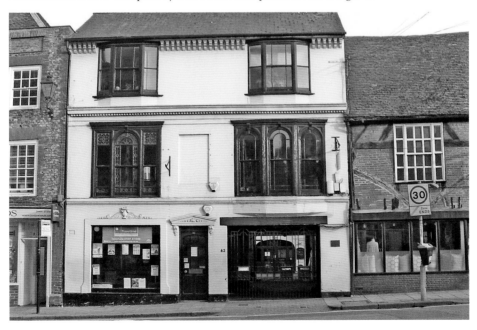

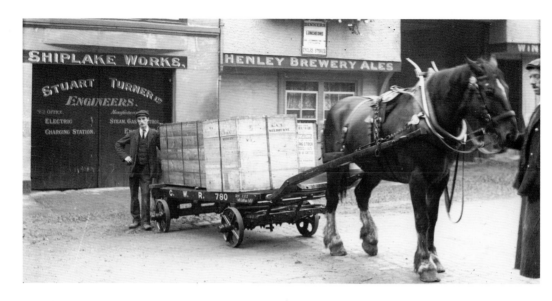

### Broad Gates Inn, Market Place, c. 1908

Broad Gates was located in an early-sixteenth-century merchant's town house, its main façade plastered with a red-brick infill, which contained the attractive feature of exposed timber framing on its exterior walls. The upper floor jutted out over the building's frontage and the structure incorporated a central carriage arch. From 1892, Broad Gates Landlord was Charles Letchford Shepherd. In 1895, his wife Eleanor Bertha died during or soon after the birth of twin girls. Charles left Broad Gates in 1907, and took the position of Hotel Keeper at No. 15 Brisbane Road, Reading. He never remarried, and his son Sydney assisted his father as the barman. Charles Shepherd died on 23 October 1924 in Little Hampton, Sussex, aged sixty-nine. Sydney (a cinema proprietor) arranged for his father's burial at St Marys, and acted as executor of Charles's estate of £4,028 11s 6d. Stuart Turner's had initially expanded into the yard behind Broad Gates. In 1917, Sidney Marmaduke Stuart Turner acquired the pub's licence and Broad Gates was closed. This unique building is now the site of Linnum, and Signals Ltd.

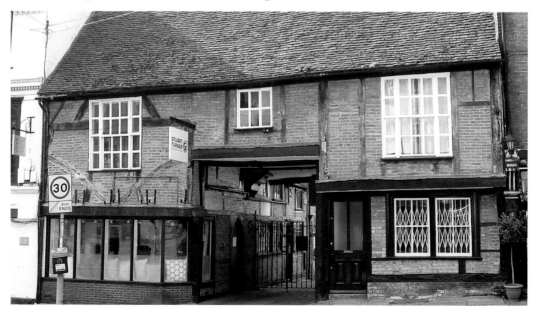

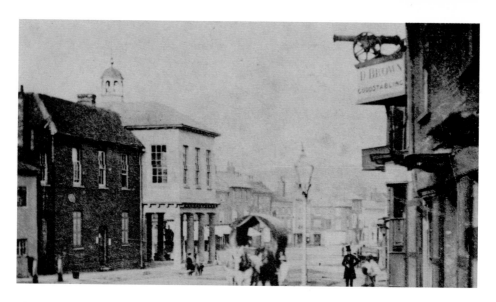

### The Cannon, Market Place, *c.* 1860s

This image is widely acknowledged at one of the earliest photographs of Henley. In the corner of the picture are the Grey Hound hostelry and the Georgian Town Hall. The photograph predated 1870, as the Town Hall still had its open colonnade. The structure that housed The Cannon was built in the early 1800s, with a later red-brick façade added to its frontage. Under the pub's projecting cannon signage (which, if real, must have been somewhat daunting to walk underneath) we can see an additional sign. It reads 'D. Brown Good Stabling' and was placed there by Landlord Daniel Brown. Daniel and his wife Elizabeth arrived at The Cannon in 1851, and ran it for sixteen years. The couple then disappeared from the area, but, by the 1870s, Daniel Brown (and second wife Mary) reappeared, working as a publican in Warfield. In the yard behind The Cannon stood a row of cottages, which were demolished under the Housing Act of 1925. The Cannon closed its doors in October 1930, and is now the location of Antico Restaurant.

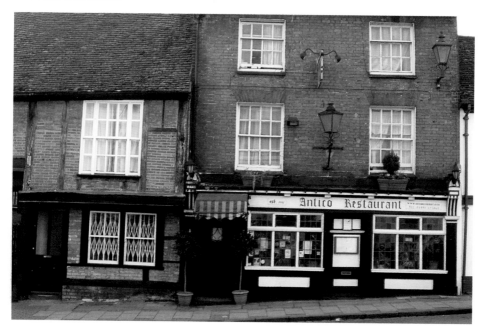

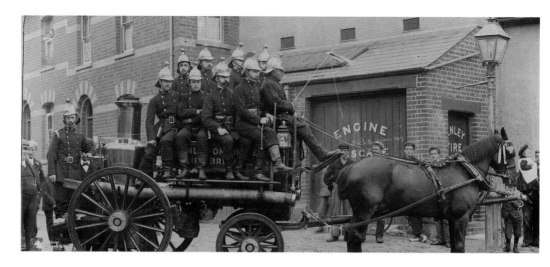

**Henley Volunteer Fire Station, Market Place, 1890s**

Henley-on-Thames, like many other expanding market towns, found itself in need of a designated fire engine. By 1750, the town achieved this goal. The engine was under the care of the Vestry, and by the 1760s the number of engines had increased to two. Safe storage for the fire engines was paramount and, in 1771, the Overseers rented commercial premises under the Georgian Town Hall. The Poor Rate subsequently provided funds to install a pump. In 1860, the Parish Engine was deemed so dilapidated that it was recommended, by the Corporation, that a replacement must be provided. The new engines were stored beneath the Town Hall, the key to gain access held at Henley Police Station, situated in Market Place. From 1864, the Local Board took on responsibility for maintaining fire-fighting equipment, and in 1866, the engines relocated to premises in Northfield End, the same year a Volunteer Fire Brigade was formed. Public subscription raised funds to assist the Henley Brigade, and in 1872, a new engine was purchased. By the early 1880s, a fire station was built at the top end of Market Place.

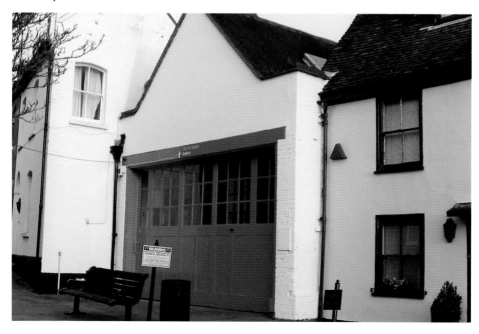

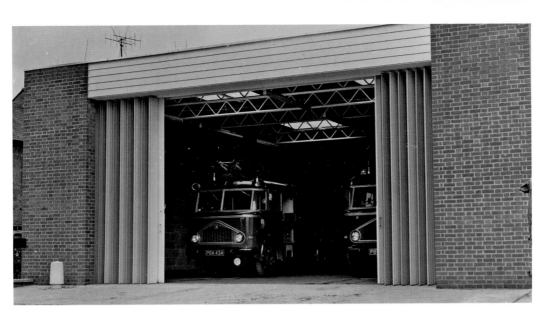

**Henley Fire Station, West Street**

The advancement of technology in the 1890s saw the arrival of a steam-powered fire engine. Edward Pratt (who lived at Somerby, No. 20 Queen Street) was Station Secretary, while William A. Hobbs (whose home was The Laurels, in St Andrews Road) was Station Superintendent. The year 1941 saw the end of Henley's Voluntary Fire Service, as from that point it came under the National Fire Service, and in 1948 it was put into the hands of Oxfordshire County Council. In 1951, a site was purchased at the bottom end of West Street. Previously known as West Hill, the area acquired was the location, at the turn of the twentieth century, of housing mainly occupied by the town's poor. The aim was to build a new fire station, though the building was not actually constructed until 1968. This fire station still serves the town today, manned by eleven retained Fire Fighters, plus the Watch Manager. The former Henley Fire Station is now used as a venue for artists, aptly named the Old Fire Station Gallery.

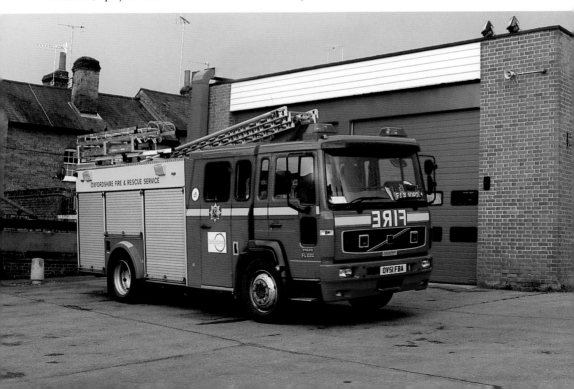

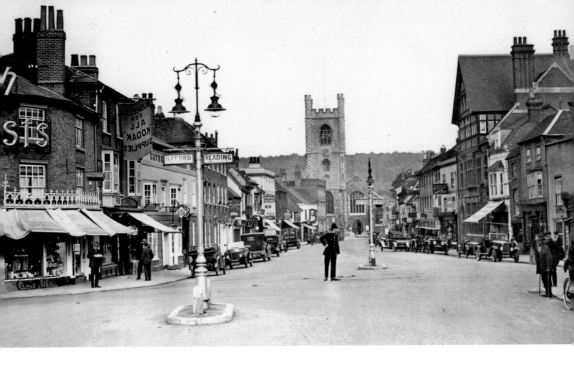

## Timothy White & Taylors Chemists, Hart Street

Although this fine, canopied structure appears to be at the junction of Hart Street, its address is in fact Nos 2–4 Bell Street. One can clearly see a section of the large lettering advertising the chemists. The company, which began as Timothy White in 1848, had merged with Taylor's Drugs Co. by 1935, and owned a substantial number of branches. Though the building was later reduced in height, and the wrought-iron detailing lost, it still has an imposing presence, the current occupier being Monsoon. One can only guess at what is going through the mind of the Police Constable, who is standing in the middle of the road, looking somewhat bewildered.

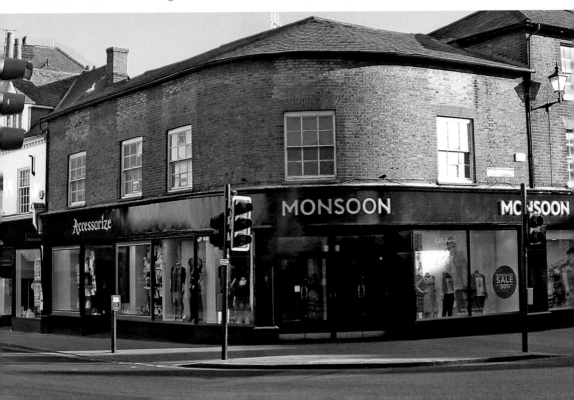

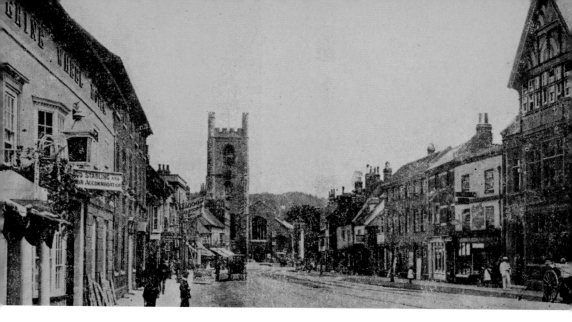

**Catherine Wheel, Hart Street, 1890s**

This image shows an inn dating from the latter years of the fifteenth century in the High Street, the previous name of Hart Street. It was known in the early seventeenth century as the 'Katherine Wheel', alluding to the saint and her wheel. With the emergence of the local coaching trade, the Catherine Wheel became one of Henley's public coaching stops. By the end of the nineteenth century, the proprietor was Councillor Charles Michael Roberts, and the establishment was run as an hotel, hostelry and location for property auctions. After Roberts' departure in 1899, the Landlord was Evelyn Stanley Dax, a London man who died in his fifties, still in occupation, in March 1905. He left his widow, Ellen, £3,178 2s. The Catherine Wheel gradually expanded to incorporate a neighbouring building, and has not moved far from its origins. It is now run as an hotel, eatery and bar by J. D. Wetherspoon.

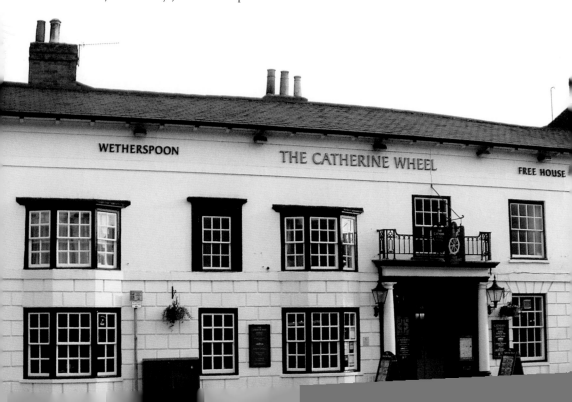

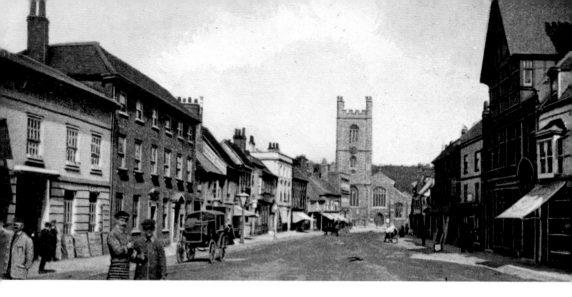

**Edward Mellett, Veterinarian, & John Walker, Manager of Simonds Bank, Hart Street**

The section of the Catherine Wheel, with the higher roofline, was, at the turn of the twentieth century, the residence of Edward Mellett, Veterinary Surgeon and Shoeing Smith. By the 1880s he was in partnership with his son. When Mellett died, aged seventy-five, on 5 December 1905, his former business premises was subsequently incorporated into the adjoining hostelry. His son, Edward James Mellett (who inherited a share of his father's estate of £7,058 14s 7d), relocated the practice to No. 33 Hart Street. The three-storey, red-brick building, across the road from the Catherine Wheel was, at the time of this image, a branch of J. & C. Simonds & Co. Bank. By 1901, it was under the management of promoted Reading Bank Clerk John Cecil Walker, who seemingly lived above the branch with Margaret and their children. John did well in his position, and the family later moved to 'The Mount' on Rotherfield Road. He died at his home, aged eighty-five, on 27 November 1949, and left £43,440 6d. The Simonds Bank was designed by W. Campbell Jones, and built by local man Charles Clements. It now has a much altered interior, serving as a branch of Barclays Bank.

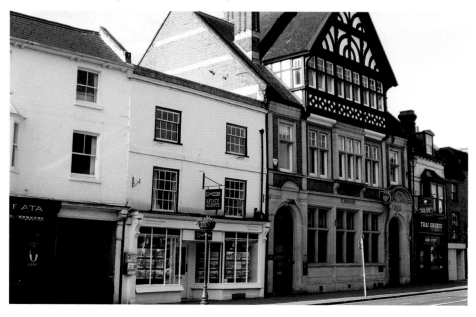

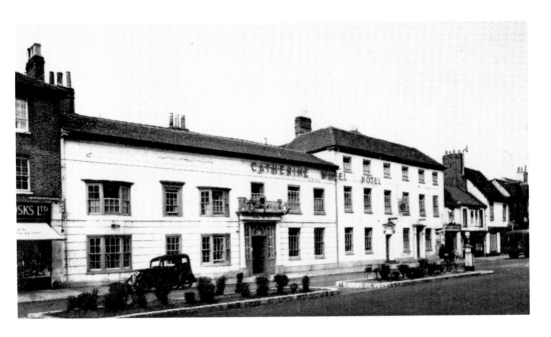

**The Catherine Wheel, Hart Street, 1930s**

We can see in this image that, by the 1930s, the Catherine Wheel had expanded, incorporating the property that had been home of Veterinary Surgeon Edward Mellett. During the 1940s, the hotel was run by Hamilton Taverns Ltd. At present it is owned by J. D. Wetherspoon, and run as a hotel, eatery and bar.

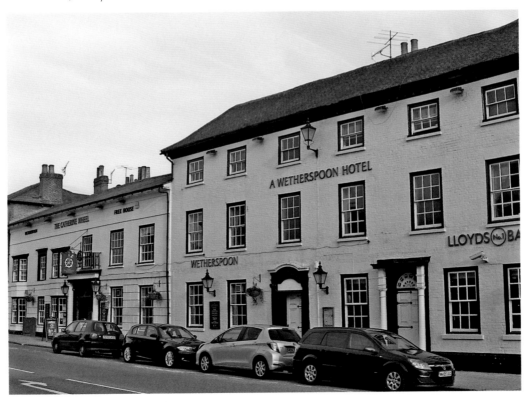

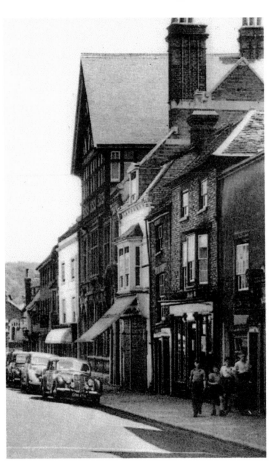

## Thomas Barnard, Optician, & Edward Giles, Furniture Dealer, Hart Street, 1940s

Thomas Barnard, a watchmaker located at No. 4 Hart Street, died aged forty-three on 2 January 1888. His widow, Mary Anne, supported her family as a jewellery maker. Her son, Thomas, took up the trades of watchmaker, jeweller and optician. He married Fanny Kate and he was still in business in the 1940s. Thomas Barnard lived to eighty-nine, and died on 28 March 1962. While the site of Barnard's, at No. 4 Hart Street, appears to be a nineteenth-century building, beneath its façade is a much older structure. It is now the location of Frost Borneo Optometrists. No. 6 Hart Street is nineteenth century in appearance, but sections of the building date from the early eighteenth century. By the 1900s, Edward Giles had begun a furniture dealership in Bell Street. After Edwards's death in 1937, his son Edward Victor Giles took over the company, which by 1907 had relocated to No. 6 Hart Street. The Giles' former shop is at present occupied by Boatique Navigational Emporium.

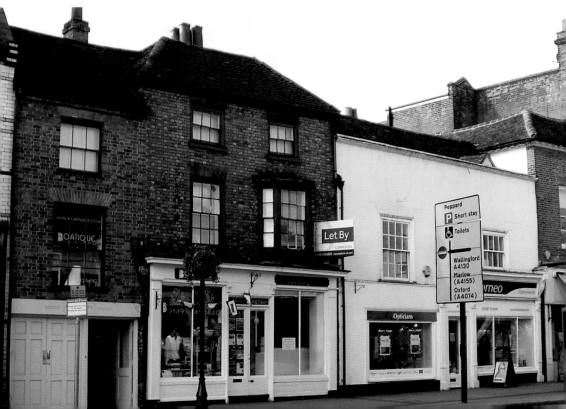

## The Henley Volunteer Fire Brigade, Hart Street

Though Hart Street appears to be an area that afforded a good standard of income, many sections of it were densely populated by those who often struggled to remain solvent. The Henley Volunteer Fire Brigade is pictured having extinguished a fire in one of Hart Street's concealed yards, though it is impossible to ascertain where the men are. At the Catherine Wheel, on 17 May 1894, auctioneer J. Chambers sold (on behalf of the trustees of the late Thomas Beckett Riggs) fourteen cottages situated in Barlows Yard, which was located to the rear of No. 6 Hart Street. The cottages were advertised as let to good tenants, and accrued a rent of £73 9s per annum. Any purchaser would have the added bonus, alongside his tenants, of the sole use of four WCs, as well as use of a water standpipe. Ex-Royal Navy Gunner, Jonas Cresswell, shared his small home at No. 6 Barlows Yard, with wife Mary and daughter Gertrude. He earned a small wage as an agricultural labourer and, after over twenty-three years at this address, died aged sixty-eight, in July 1903. Barlows Yard is now made up of commercial and residential premises, and the empty building pictured is situated to the rear of No. 16 Hart Street.

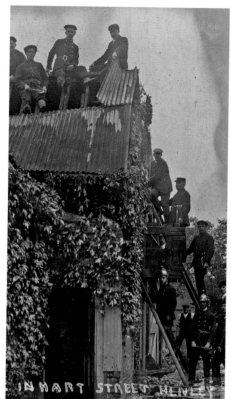

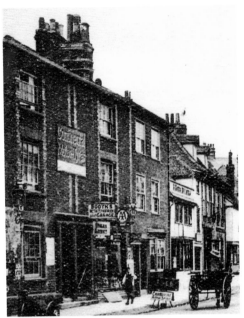

## Booths, Cycle Maker and Agent, Hart Street, 1900s

One can see the prominent sign mounted on the front of the three-storey Georgian building that advertises Continental Motor Tyres. Nos 34–36 Hart Street was the business address of James Booth, born 1847 in High Wycombe. Having earlier concentrated his efforts in manufacturing bicycles, by the second decade of the twentieth century he had diversified. This enterprising businessman then began to provide parts to his ever expanding customer base of motorcar owners. James was not to enjoy this new opportunity for long, leaving his wife Jane a widow when he died in December 1915. His sons, John and Richard, carried on, in some way, their father's legacy, since both men qualified as engineers. James Booth's former shop is now the site of Jack's Gallery.

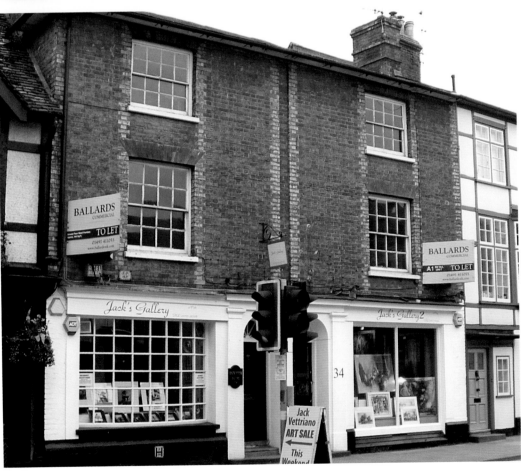

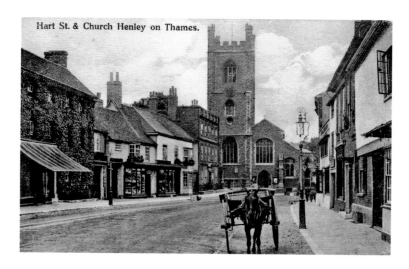

Hart St. & Church Henley on Thames.

## Marsh Brothers, Hart Street

One cannot help but notice the ivy covered, three-storey Georgian building with the striking, striped canopy. In the latter years of the nineteenth century, Nos 31–33 Hart Street were the business address of James Marsh Photographic Artists. James' professional career was previously that of a Victualler, the family living in Queen Street. Marsh turned eighty in 1898 and ran the studio assisted by sons Harry, Tom and Frederick. Their enterprise seems to have been profitable, with Frederick and wife Jessie moving on from their home in Greys Hill to No. 7 Caxton Terrace, Station Road. The building on Hart Street was of a considerable size, and the photographers shared its floor space with Davy & Salter Architects and Surveyors. James Marsh died in 1906, at the advanced age of eighty-eight, his sons carrying on the business. One half of the retail premises is, at present, empty, the other section occupied by ladies boutique Foam Fashion.

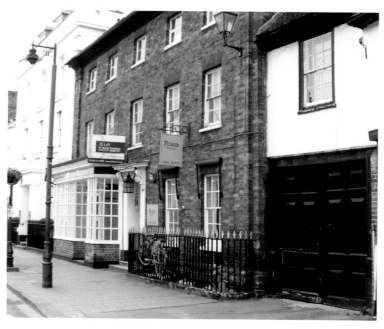

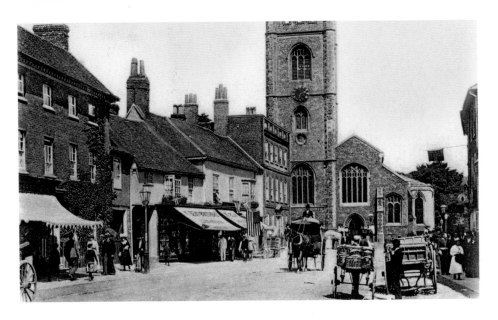

### McBean Brothers, Ironmongers, Hart Street, 1900s

Looking down towards St Mary's church, at Nos 35-37 Hart Street, the building with the triple canopy was, from the 1870s onwards, the retail premises of John McBean, born 1841 in London. The services offered by this individual were varied indeed: as well as being a general Ironmonger, the gentleman was a Whitesmith (one who repairs tin items), a stockist of Bar Iron, a Colour Merchant and a Bell Hanger. John McBean died on 18 February 1905, and left an estate valued at £4,792 17s 9d. His widow, Nellie Susan, moved to Bournemouth shortly after her husband's death, and was able to live on her private income. She enjoyed a long retirement by the sea, and died aged eighty-one in 1932, bequeathing £145 1s 2d to her unmarried daughter, Constance. The former site of the McBean Brothers is, at present, split into three outlets, White Garden Florists, Café Rouge Restaurant and Cannelle Beauty Salon.

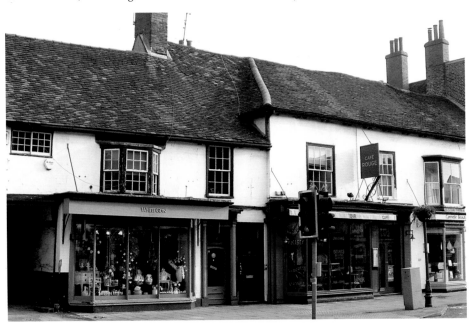

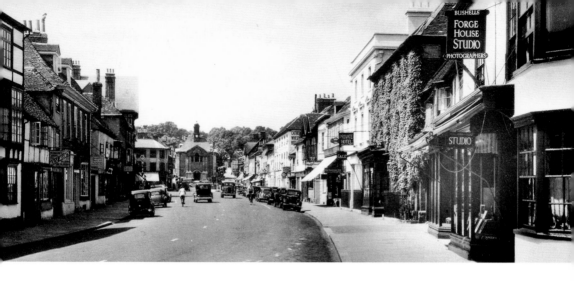

## Bushells, Hart Street, 1930s

George Bushell was born in 1880, in Tunbridge Wells, Kent. He married in 1905, and by the second decade of the twentieth century he and wife Margaret lived at No. 26 Clausentum Road, Winchester. In 1919, the Bushells arrived in Henley, and George set up a photographic business at No. 3 Hart Street, aptly named George Bushell Photographers. He was later joined in the company by his eldest son, Kenneth Howard, and the business name was changed to George Bushell & Son. In 1936, Kenneth left the photographer's and established Bushells Radio at No. 33 Duke Street. His father relocated to the site of a former tea room at No. 37 Hart Street, and renamed the premises the Forge House Studios. George was later joined in the business by his second son, Brian William. George Bushell died in 1965, and in 1967 his grandson George joined the business. In 1983, he split the building into two shops and ran George Bushell & Son until 1989, when the business was sold. The former site of Bushells is occupied by Café Rouge and Cannelle Beauty Salon.

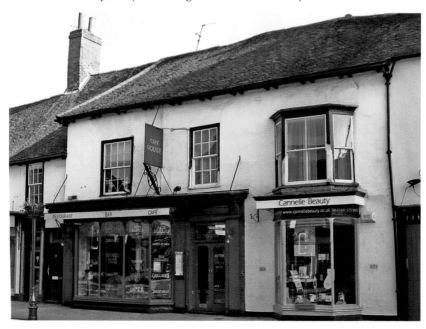

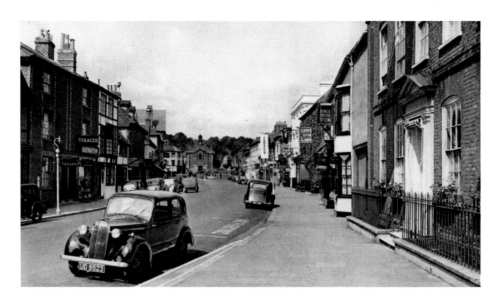

**Longlands, Hart Street, 1930s**

The elegant, three-storey building is Longlands. From the 1900s until the mid-1930s, this was the home of Doctor George Smith, a Scot, who took up the appointment of Medical Officer and Public Vaccinator for the Parish of Rotherfield Greys. Incidentally, George lived to 100, dying in 1961 in St Agnes, Cornwall. He was buried at Remenham, alongside his wife Laura. Longlands is Georgian in appearance, but its façade conceals a much older structure, its name derived from Henley man John Longland, who as well as being appointed Bishop of Lincoln, had the unenviable task of being Henry VIII's Chief Confessor. Longlands House was for many years commercial, but has now been converted back to residential premises.

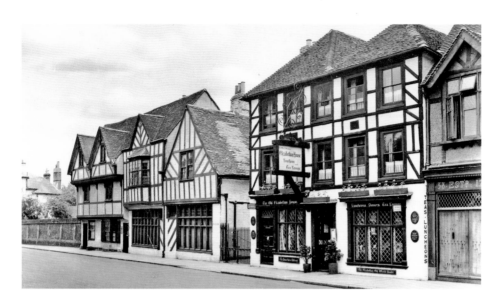

### Speakers House, Hart Street, 1930s

Hart Street (formally known as High Street) ran from Henley Bridge into what is now Market Place, the road now ending at the junction of Bell Street, Duke Street and Market Place. Its name is derived from The White Hart Coaching Inn. In the 1930s, the impressive building positioned alongside Ye Olde Elizabethan House Café was the surgery of Smith, Susman & Staines-Read Physicians & Surgeons. It is to be noted that this example of a fine medieval house is timber framed, and would more than likely have incorporated a central hall, the building open to its rafters with heating provided by an open hearth. Speakers House, its frontage somewhat altered since the 1930s, is now a branch of Sotheby's International Realty, the company having spent some considerable time and care in restoring the building.

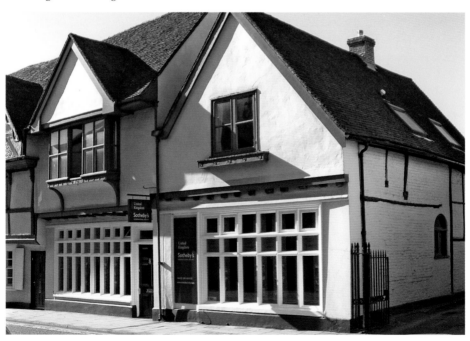

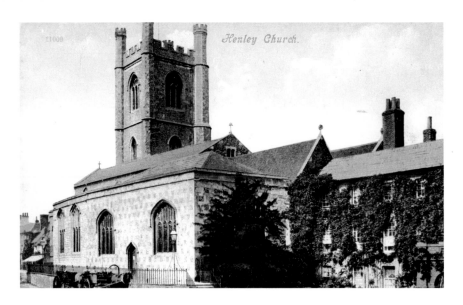

## St Mary's Church, Hart Street

St Mary's is situated in Hart Street, and it is widely thought that in its original form it stood in Henley from the thirteenth century. In the 1400s, the church was considerable enlarged; a small stone-built chapel (dedicated to Saint Leonard) was constructed on the orders of Sir John Elmes. It was used as a 'chantry', where Masses were held on a daily basis for Elmes and his family. By the 1500s, St Mary's had a heighted central pier with eastern and western bays, and in the sixteenth century, a tower (funded by John Longland) was incorporated into the structure. Dame Elizabeth Periam's alabaster monument was badly damaged during the Civil War, but in 1711 it was restored at the charge of Richard Jennings, Master Carpenter of St Paul's Cathedral. It is to be noted that her monument is not in its original location within the church, having been relocated twice during restoration works. St Mary's impressive stained-glass windows, on the most part, were commissioned and paid for by the Makins of Rotherfield Court.

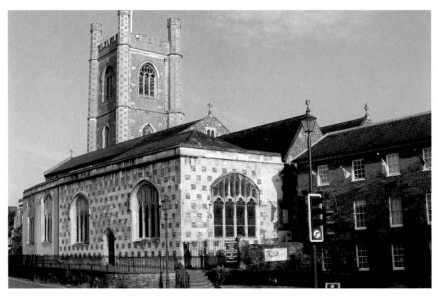

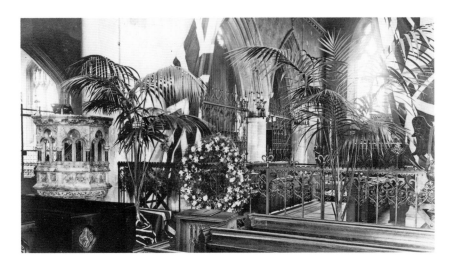

### St Mary's Church, Hart Street, Palm Sunday

St Mary's was to reach the form that can be seen today in the 1850s, the works prompted by the poor state of some aspects of the building. From 1852 Thomas Baker Morrell served as Rector of St Mary's, an individual with considerable private means. During his time at St Mary's, Morrell oversaw large-scale alterations to the church. This involved removal of the galleries, installing stained-glass windows and a new flooring, which obscured many ancient tombstones, and railings being erected along the terrace. The alterations took two years to complete. Morrell paid half of the build's £6,000 cost. Thomas Baker Morrell commissioned the construction of Gothic style mansion Rotherfield Court in 1861 (designed by Mr Wooyer of Oxford, now the old block of Henley College), but he only lived there for a short time. He left St Mary's in 1863, and died aged sixty-two, on 15 November 1877. Morrell's estate (bequeathed to his widow Francina Maria) was valued at just under £35,000. The marble pulpit in the photograph was gifted in 1897 by Lady Catherine Crisp of Friar Park, and the modern image was taken on Palm Sunday 2014.

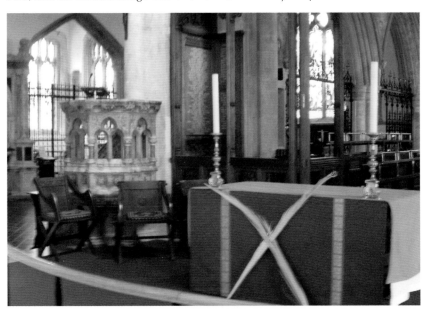

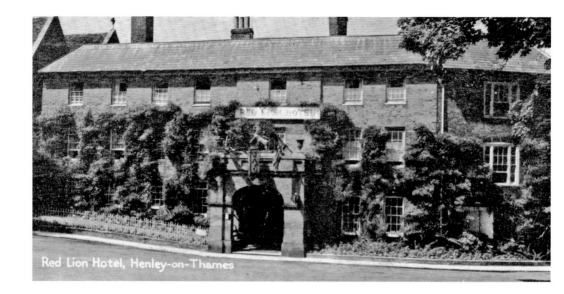

Red Lion Hotel, Henley-on-Thames

## Red Lion Hotel, Hart Street

This hostelry has stood on this site for many centuries; the building's three-storey wing is more than likely the original Red Lion. The 1532 will of Robert Kenton makes reference to the 'Lyon', and King Charles I is known to have favoured it. Thomas Shepherd took on the Red Lion as Landlord and boat builder in 1888. On 17 November 1898, Frederick Harrison was the last person to see Shepherd alive. Thomas retired for the night, but at 11.45 p.m. the cook heard her master fall, and found him at the foot of twenty stone steps. A lad who worked at the Red Lion was sent to fetch Doctor Browne, but Shepherd succumbed to his injuries before he arrived. The inquest was held at The Red Lion, in front of Dr Dixon, Coroner for South Oxfordshire. Shepherd's body was laid out to be examined by the jury. Dr Browne's opinion was that an apoplectic seizure had caused the fall, and the verdict agreed with his findings. Thomas Shepherd's funeral was held at the Red Lion on Monday 21 November, and the deceased left his widow Mary Bryce £34,000. By the turn of the twentieth century, Mary was living with sons Thomas and Harold, and daughter Vera at No. 27 Queen Street. By 1911 she had relocated to 'Haneburg', on Church Street. Mary Shepherd died on 13 December 1923, aged sixty-nine, at her home, No. 112 Peckham Road, Peckham, Surrey. The Red Lion is still run as a hotel, with an international clientele.

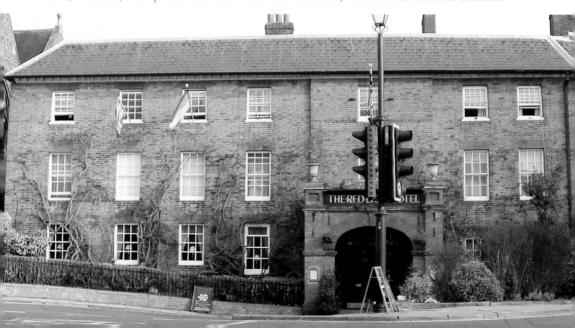

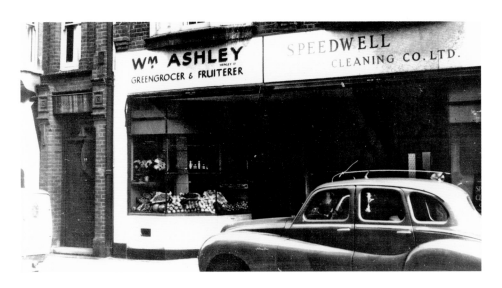

**W. Ashley, Greengrocer & Fruiterer & Speedwell Cleaning Co. Ltd,
Bell Street, 1940s**

Daniel Burgis ran a successful 'Grocer, Tea and Provisions Shop' at No. 33 Market Place. When he died in 1877, his son Daniel took on his father's shop. Business was good and by the closing years of the nineteenth century Daniel had opened a second branch, located at No. 8 Bell Street, aptly named Daniel Burgis Grocer and Provision Merchant. Daniel's son, Frank Harding Burgis, was, like his father (who died in 1910) a successful grocer, and by the late 1920s he had branches at Nos 29–33 Market Place and No. 14 Duke Street. After Burgis quit No. 8 Bell Street, the National Provincial Bank opened a branch at the address. By the 1930s, Edgar Meadow's Fruiterer & Greengrocer was located at No. 8, later replaced by William Ashley Greengrocer & Fruiterer. In the 1940s, No. 8a Bell Street was the location of Speedwell Cleaning Co. Ltd, and by the 1950s had been replaced by Chiltern Dry Cleaners. The building is at present occupied by Anthony Paul Jewellery and Café Buendia.

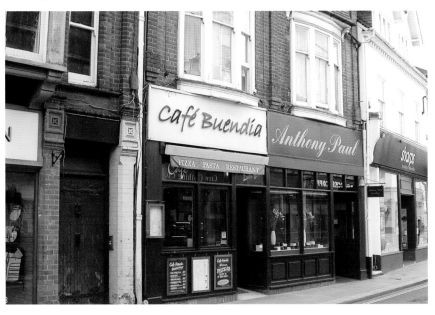

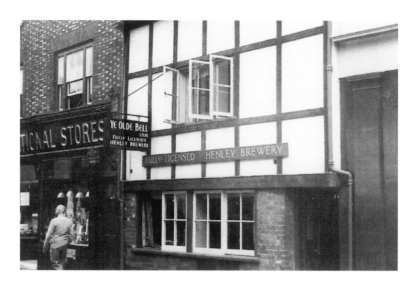

**Ye Olde Bell, Bell Street, c. 1950**

Bell Street was formally known as North Street, and ran from Market Place Cross to Northfield End. It was subsequently renamed after the Bell Inn, which stood at Northfield. This hostelry was later closed, and it became the site of Henley Grammar School. It is now two private residences. Ye Olde Bell (formally known as The Duke of Cumberland, and renamed after the Bell Inn) was in fact a conversion of a wing of a timber-framed residential premises. The Bell was re-fronted in 1920, but recent analysis has revealed the older structure concealed behind. Original posts and studs in the ground-floor north wall survive, as well as crown posts in the attic spacing. The building dates back to 1325. The first Landlord to run the newly named Ye Olde Bell was a former Council Gas Works Stoker, Oxford born Walter Bowers. He ran the hostelry for four years, until his death in 1924. The pub, now known as The Bell, is still to this day, a favoured drinking establishment.

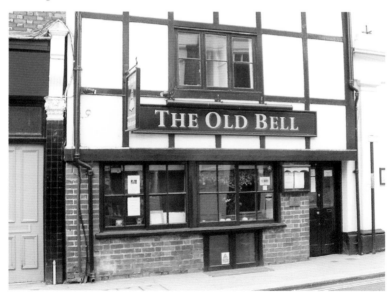

## Simmons & Sons, Bell Street, 1930s

Simmons Land & Estate Agents, Auctioneers & Valuers was run by Shiplake farmer William Simmons. Initially, he worked out of premises in Northfield End, and later relocated to No. 18 Hart Street. The building pictured (known as 'Crandem Gate' the build date 1763 engraved on its rear brickwork) was acquired by William's son Charles. When Charles died in 1910, his former home was converted into Simmons' principal office. His sons, Charles Franklin Simmons and William Anker Simmons, took over the reins, the company having expanded into Reading and Basingstoke. William and his wife Sarah occupied 'Wilminster Cottage', and he served as Henley Mayor on four occasions. Sir William Anker Simmons died suddenly, aged sixty-nine, on Thursday 20 October 1927 at 'The Hermitage', Vicarage Road, having just returned from a motor trip to Maidenhead. His last home was 'Bird Place', situated over Henley Bridge, in the Parish of Remenham. Simmons & Sons Surveyors & Land Agents still operate from their Bell Street premises.

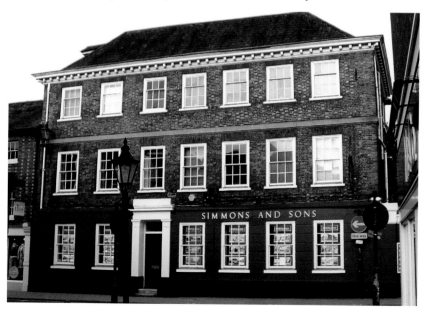

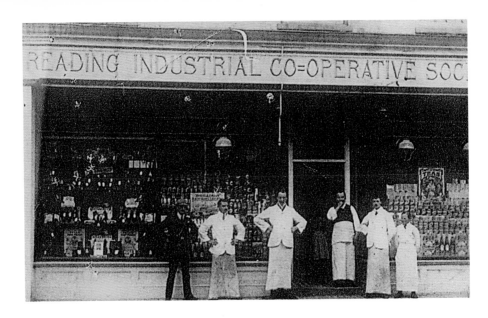

### Reading Industrial Co-operative Society, Bell Street, *c.* 1910

The above building is a former residential property, constructed in the late eighteenth century. It was considerably altered in the nineteeenth century, with the addition of a façade and parapet. Retired 'Park Place' Farm Bailiff, Enos Clerk resided at No. 52 Bell Street by the mid-1890s, and carried on the trade of gardener. The Reading Industrial Co-operative Society was conceived by Stephen Gyngell in 1860. Members could purchase shares and vote at the General Meeting, and they were obliged to join a trade union. Around 1907, a branch of the Co-operative opened at the former address of Enos Clerk (he had moved to 'Rose Cottage' on the Reading Road), its members generally selling groceries. Business was good and the shop remained in Bell Street some twenty-two years, before relocating to Market Place. Unfortunately, in 1956, the Market Place outlet was put into liquidation. The Industrial Co-operative's former Bell Street site is now occupied by the independently owned Bell Bookshop.

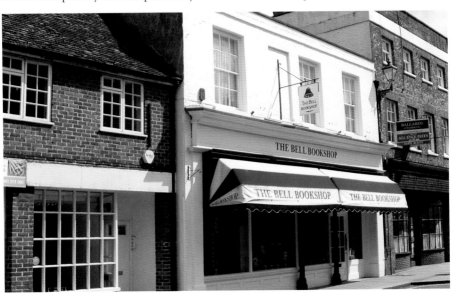

**The Bull, Bell Street, *c.* 1972**

The Bull Inn is a fifteenth-century construction, and is mainly timber framed with a plaster infill. In the late seventeenth century, the structure was much altered, but some original framing remains. James Froud (who died in 1891) was a successful farmer, and held 65 acres in Assendon. In 1895, his son, Lewis Edward Froud, took on the position of Landlord of the Bull in Bell Street. Lewis and his wife Edith quit the Bull in 1911, and he reverted to his original profession of joiner. Lewis Froud died in Wokingham, aged sixty-six in September 1932. It is interesting to note that James Froud & Sons Steam Saw Mills (run by Lewis's brother), located in Badgemore, was still in operation well into the twentieth century. The Bull is still to this day a popular drinking establishment.

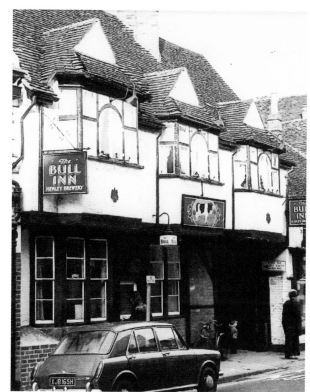

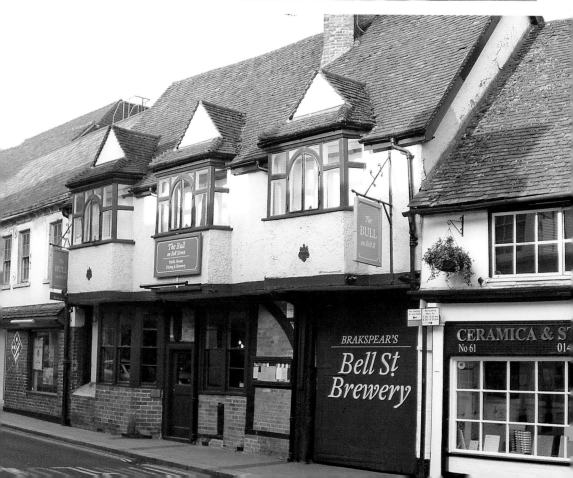

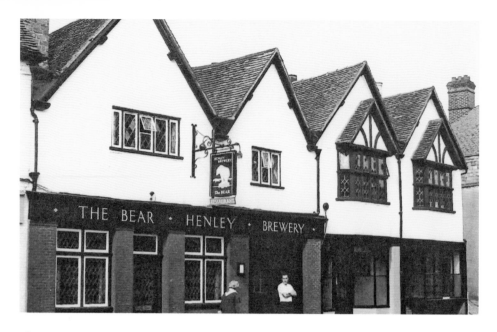

### The Bear, Bell Street, c. 1972

The Bear can be dated to the 1430s, some of its timber framing clearly visible in its walls. The building had seventeenth-century additions, which later included an impressive carriageway arch. It subsequently had its frontage adapted, with the addition of a brick façade . In the 1840s, John William Banbury and his wife Elizabeth lodged with the Clements family in Bell Street. By the 1850s, John had secured the position of Coach Porter at the Bell Tap Public House in Bell Street. From 1861, he took on the role of Landlord of The Bear Inn. After her husband's death in 1871, Elizabeth ran the Bear until 1873; she then relocated to The Oxford Arms at No. 89 Bell Street, where she was the Landlady until it closed in 1885. The Bear was subsequently reduced in size, and by the 1970s its signage depicted a Polar Bear, which caused much dissent among the locals. It closed its doors in 1989, the last Landlord being Mr Edward Randolph. The premises are now divided into three outlets, occupied by Henley Hair & Beauty, Brookstones Residential Lettings, and Aura Creative Integrated Marketing.

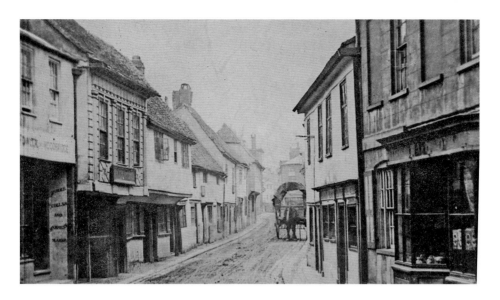

## Duke Street, early 1870s

Duke Street was formally known as Bridge Street, as a stream (spanned by a small bridge) runs along it, and the area was subsequently called Duck Street. Later it was renamed after the Dukes Head Public House. In the 1890s No. 27 was occupied by Henry James Riggs, his business dealing with the sale of corn, hay and seed. Henry, who also had business premises at No. 11 Greys Road, died in 1913 at the relatively young age of forty-five. Nos 29–31 were previously the location of the Crown Beer House, in 1899, under Landlord William Whiting. By the end of the 1890s, half of the building had been let to Stanley Mead, and when the pub closed in 1909 he took on the whole building. Stanley Alfred Mead was primarily a hairdresser, but alongside his wife, Edith, he also manufactured umbrellas. Nos 27–31 Duke Street are now the locations of Sullivans Menswear, Laurence Menswear, and The Sole Man.

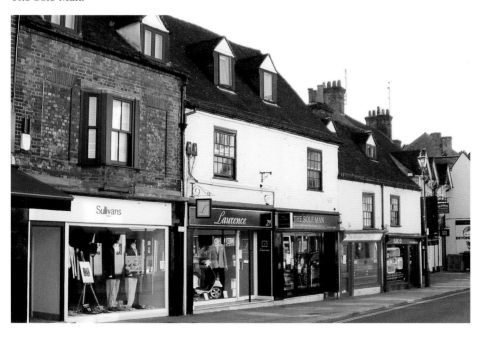

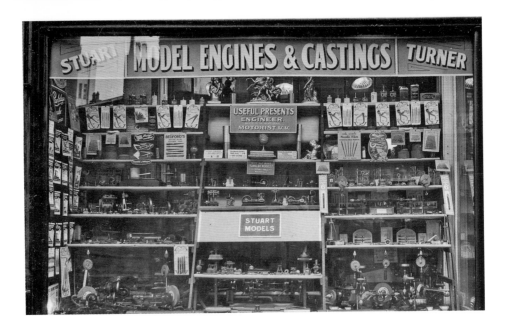

## Stuart Turner's Shop, Duke Street

The early 1870s rebuild of the west side of Duke Street, for the purpose of road widening, led to the compulsory purchase and demolition of the area's entire stretch of cottages, workshops and retail outlets. Those who subsequently secured development rights were expected to construct a retail outlet with residential premises above. The newly constructed properties were quickly let, and those who occupied them had a diverse assortment of trades, such as Charles Edmund, a Carver and Gilder, and the aptly named William Stoker, a Coal Merchant. Duke Street remained a popular retail area into the twentieth century, as can be seen by the shop window of Stuart Model Engines & Castings. This shop sold an eclectic range of goods for the engineer and motorist, and you could also be one of the first to purchase the 'Micrometre'. Stuart Turner's outlet is now the location of Estilo Ladies Boutique.

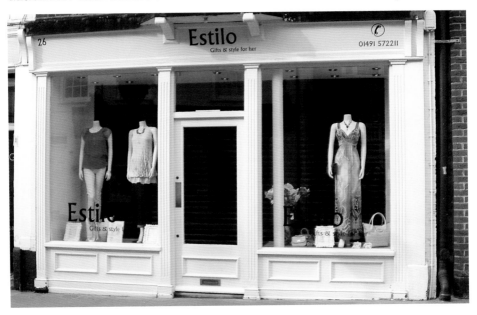

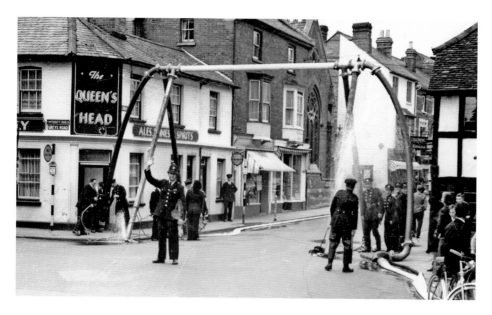

## The Queens Head, Duke Street, 1960s

Thomas Gregory secured employment as a Game Keeper in the late 1850s, and he and wife, Ann, moved into 'Harpsden Cottage' in Harpsden Village. In 1870, Gregory took the job of Landlord of the Queens Head. The hostelry was demolished and rebuilt, sometime during the early 1870s redevelopment of the west side of Duke Street. Gregory must therefore have run the newly built Queens Head, which stood on the corner of Duke Street and Greys Road. He quit as landlord in 1877, but remained in Duke Street, employed as a greengrocer and carpenter. After Thomas died in 1887, life as a widow proved financially challenging, and by the late 1880s Ann resided at one of the Ann Messenger Almshouses. In the photograph taken in the 1960s, the activities of the firemen look somewhat alarming, but it was in fact only a practice drill. The Queens Head finally closed its doors in 2014, and is now the site of Pachangas Mexican Restaurant.

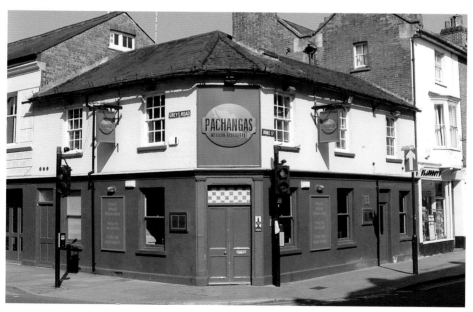

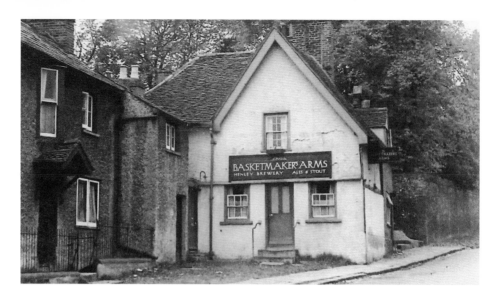

**The Basketmakers Arms, Gravel Hill, *c.* 1950**

The Basketmakers Arms is now widely accepted as having aspects of its construction that date from the sixteenth century. The oldest parts of the structure are its two exterior projecting bays, the later addition of a large, interior chimney block dividing what was probably an Open Hall House. The first official Landlord was Henley man Thomas Usher, who from 1841 ran it as a beer and lodging house. Thomas and his wife, Elizabeth, saw many lodgers, such as William Morris (an umbrella maker) and his family. Thomas Usher left his position as Landlord in 1869 and moved to Greys Hill, where he took work as a general labourer Thomas died at the Henley Union Workhouse, aged eighty in 1879. By the 1880s, the Basketmakers Arms was owned by Brakspears, though curiously it was not granted a full licence until 1960. It closed its doors for the last time on 1 February 1972, and was subsequently converted into a residence.

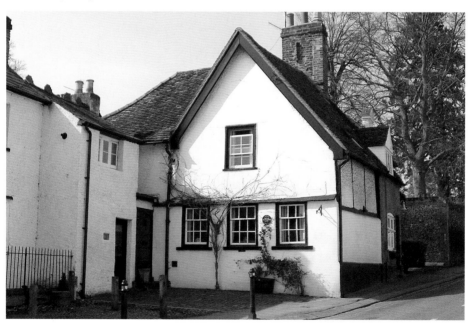

## No. 45, Gravel Hill, c. 1950

During the 1890s, John Wooten resided at No. 45 Gravel Hill alongside his wife Minnie and their two children. As John earned his wage as a general labourer, the household income was assisted by the addition of a lodger. Thus, Arthur Willis, a boat varnisher, lived alongside the Woottens. The Woottens eventually moved into one of the recently built terraced homes at No. 6 Niagara Road. John was now employed as a gardener, and thus more likely able to afford the rent, but Arthur Willis remained part of the equation, just to bolster the coffers. John Wooten worked hard throughout his life, and died aged sixty-four in 1931. He was buried in Trinity churchyard on 2 September, and Minnie was reunited with her husband in December 1946. The property at No. 45 Gravel Hill, which has been home to many of Henley's poorer inhabitants, is today, privately owned.

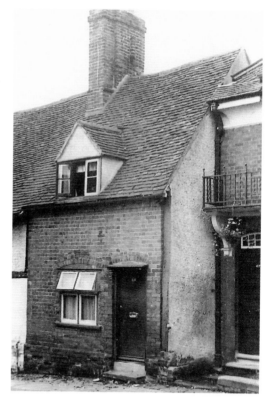

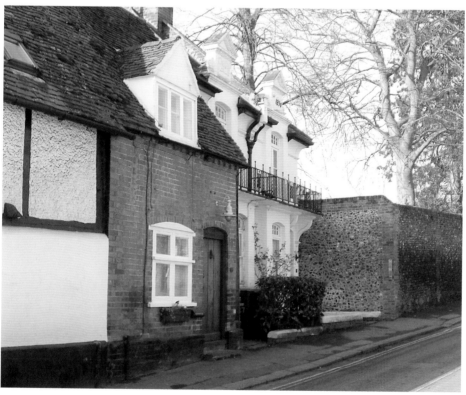

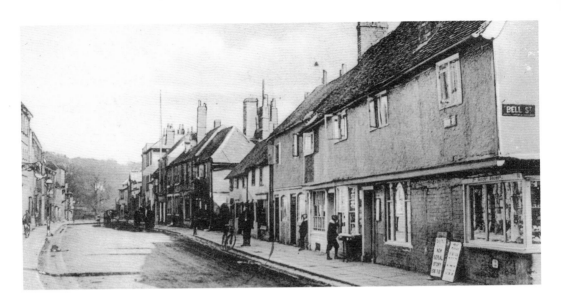

## The Old Cottage, New Street, 1900s

The Old Cottage, positioned at New Street and Bell Street corner, consisted of two knocked through, timber-framed cottages, which dated from the early 1500s. Later, the building was used for retail, the location of the frontage and doorway altered over the years. In 1899, the frontage at No. 58 Bell Street was occupied by William Chessall, a tobacconist and hairdresser. In the last years of the nineteenth century, No. 2 New Street was the location of the Park Corner Dairy, under the management of Edwin Wise, assisted by his wife Mary. In the 1890s, the adjoining section of the building, known as No. 4 New Street, was occupied by Alfred Wells. The property was auctioned by Simmons & Sons on 12 September 1918, the retail section occupied by James Annereau. By 1920, James was running a confectionery shop at No. 4 Bell Street. The building was again auctioned by Baxter Payne & Lepper on 30 July 1924, at the London Auction Mart. The adjoining cottage was included in the sale. This impressive building, which is now knocked through to incorporate No. 4 New Street, makes a fascinating visit. Its original features are still much in evidence, and it is now the location of Asquiths Teddy Bear Shop.

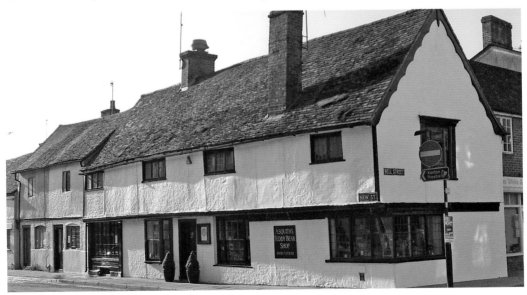

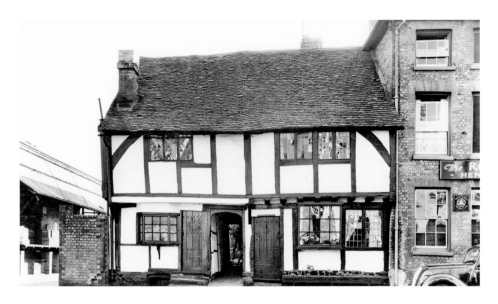

### Anne Boleyn Cottage & Tudor Cottage, New Street, *c.* 1948

These quaint timber-framed cottages have stood on this site since the fifteenth century. Their structure altered during the 1600s, and the projecting windows were added during the eighteenth century. There are additional cottages located down the central 'Tudor Arched' passage, and these represent the building up of a Burgage plot. Many individuals, no doubt, have lived in the cottages, and we can get a snapshot of two of them from the 1911 census. Ann Boleyn Cottage was the home of agricultural labourer James Shepherd, his wife Elizabeth Ann, and their three sons. Tudor Cottage was the home of Roderick and Elizabeth Windebank. During the First World War, Roderick was conscripted to serve as a Private in the Royal Army Ordnance Corps. Having been injured, he died aged forty-two, on 7 November 1918, at the Portsmouth Military Hospital. The cottages are still occupied, and their charm has not diminished.

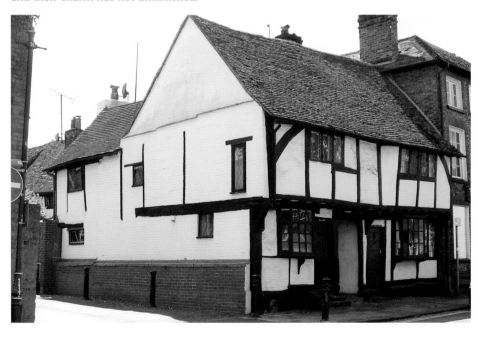

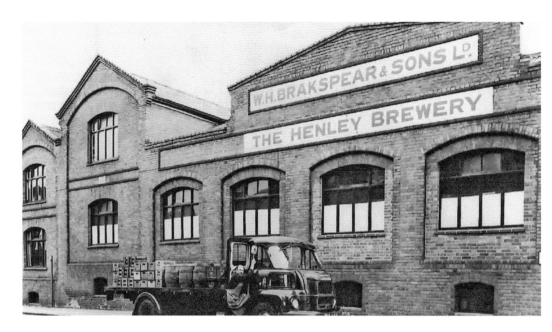

## Brakspear Brewery, New Street

Robert Breakspear (born in Faringdon) was the nephew of successful Henley brewer Richard Hayward. As Richard had no offspring, he invited his nephew to come in as a partner in his Bell Street brewery. Thus, in 1779, Robert arrived in Henley, and by 1781 he secured a partnership with his uncle and Benjamin Moorhouse. When Richard died, Robert (now known as Brakspear) was left his uncle's brewery interests, and by the end of 1803 had bought out Moorhouse for the sum of £1,300. Robert Brakspear died on 22 November 1812, and his ten-year-old son, William Henry, was named as his successor. This young boy did his father proud and subsequently relocated the brewery to New Street. William became sole owner in 1848, and henceforward the company was known as W. H. Brakspear & Sons. William Brakspear died in 1882, and his sons Archibald and George took on the company. Brakspears brewery site was sold in 2003, and is now the location of Hotel Du Vin.

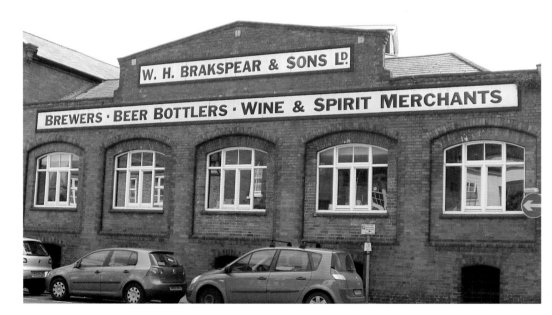

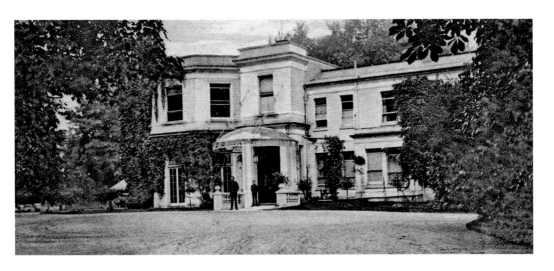

## Phyllis Court Club, Phyllis Court Drive

As Reginald Edmund Alexander Finlay and family sailed past the vacant riverside estate of Phyllis Court, his son, Roy, suggested that his father could run it as a country club. Reginald, a canny Scot, saw the business opportunity, and on 7 June 1905 the family threw a party to celebrate the lease of Phyllis Court from its owner, William Dalziel Mackenzie of Fawley Court. Celebrations were short-lived, as Reginald contracted pneumonia and passed away on Friday 13 April 1906. After much negotiation, Phyllis Court's lease was reassigned to Roy, on a twenty-one-year term. Due to the family's bereavement, Phyllis Court Club was launched with a subdued event on Saturday 7 June 1906. The estate was eventually auctioned off by the Mackenzies, and Roy acquired the freehold in the 1920s. Roy Finlay died (still in ownership) aged seventy, at 'Trevor', Lashbrook, Shiplake, in 1952. Phyllis Court Club is still in existence as a popular and vibrant riverside establishment.

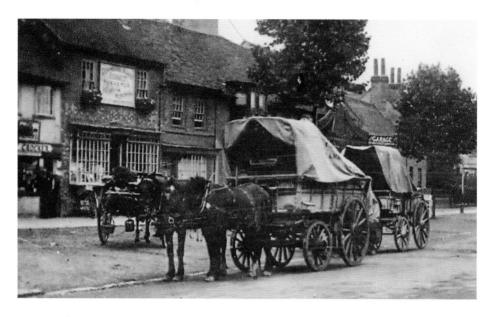

### S. E. Crocker & S. Bennett, Northfield End

The white-fronted building, with the signage for S. E. Crocker, was a timber-framed structure of some age, with a façade added to its frontage in the nineteenth century. By 1891, Henley born Samson Ezekiel Crocker was trading as a shoemaker and boot dealer, situated at No. 21 Northfield End. By the turn of the twentieth century, Crocker's son, Samson Ezekiel Heath Crocker, assisted in the business, which was located at No. 55 Bell Street. Directly next door to Samson Crocker, at No. 23 Northfield End (a structure which predates its late eighteenth-century façade), was the premises of Devon born Samuel John Bennett. Bennett ran a provisions shop, as indicated by his somewhat difficult to miss shop signage. The Crockers remained in business for several generations, and their former Northfield End shop, and Bennett's, are now converted to residential dwellings.

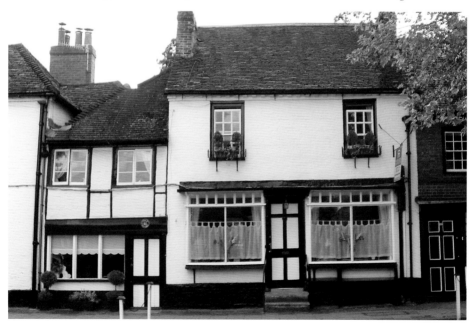

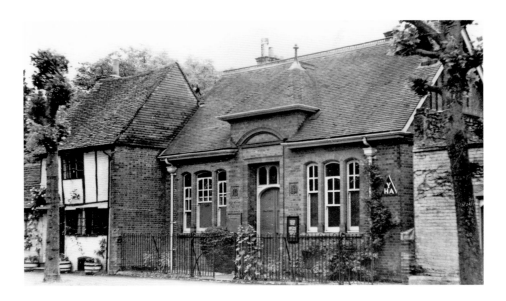

## Friends Meeting House, Northfield End

In 1672, two cottages were purchased by the Friends (Quakers) for use as a place of worship. The adjoining two cottages (a carpenter's yard) were subsequently bequeathed to the Friends in 1727. Meetings were held in the western end of the cottages, and the congregation was fairly small and consisted, in the most part, of local families such as Bell Street grocer, Joseph Theobald, who attended meetings with his wife Hannah. In 1894, one of the cottages was demolished and a red-brick and red terracotta structure was built, to the designs of Smith & Son of Reading. The Meeting House contained a meeting room to its front, with a school to its rear, and could accommodate 150 worshippers. In 1934, the Friends let the building to the Youth Hostel Association, who converted its interior into dormitories, the hostel's warden occupying one of the neighbouring cottages. From the 1960s, the Friends used the building's common room for their weekly meetings, and in the mid-1980s the Youth Hostel Association quit the site. Thus, the Friends chose to meet in the building's West Room, and let out other areas to various community groups, a practice that carries on to this day.

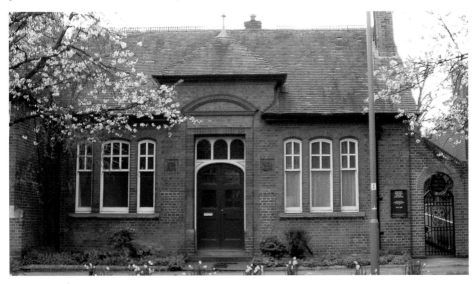

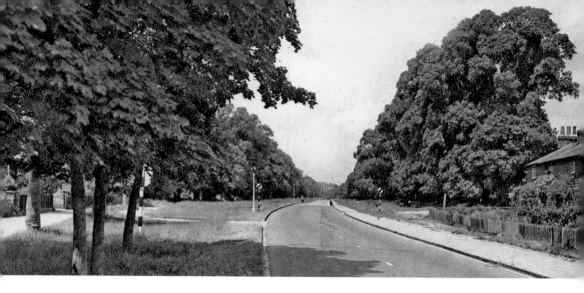

## The Fairmile

The road that runs from Dorchester and Wallingford, and enters Henley along the Fairmile, is almost certainly of a Roman or earlier origin. In 1993/94, a substantial Romano-British structure was excavated under the site of Waitrose on Bell Street, which indicates Roman occupation of the town. In the Middle Ages, the Fairmile was less favoured and thus fell into disrepair, but by the seventeenth century, with increased coach traffic, it was again a main thoroughfare. In 1804, Strickland Freeman of Fawley Court constructed a flint and brick boundary wall (still standing) to his Henley Park estate, on the east side of the Fairmile. In doing so, he blocked a public footpath that ran from Northfield End and on up to his estate. Strickland was thus ordered by the Henley Corporation to provide a gap in the wall. The Fairmile's appearance was considerably enhanced in the nineteenth century by the planting (upon the orders of Sir William Stapleton) of a row of trees, and by the 1880s, large, semi-detached villas (such as Mountview Villas) were constructed. A municipal cemetery, built on land acquired from Edward Mackenzie of Fawley Court, was consecrated in 1868. The churchyard provided with two chapels, one Anglican and the other Nonconformist. The Smith's Isolation Hospital (built at the expense of W. H. Smith, now the site of a private company), with accommodation for fourteen patients, was opened on the Fairmile in 1892. The Fairmile still retains many of its Victorian structures, and is a busy access road into Henley-on-Thames.

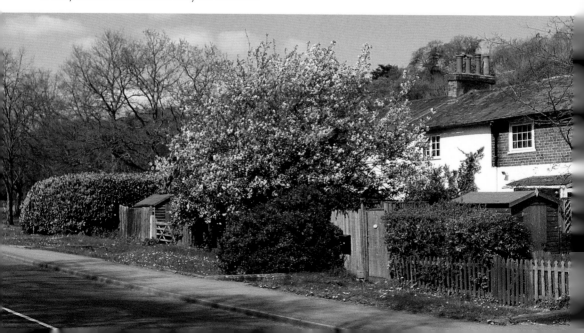

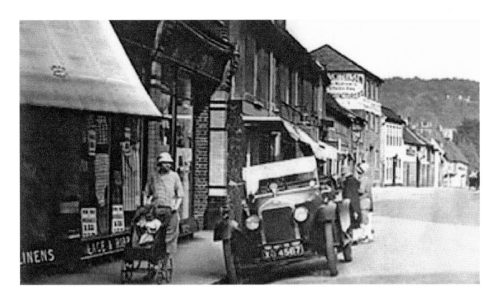

## Wheeler Brothers, Friday Street, 1920s

At 4 o'clock on 29 September 1898, the property known as 'Greyton House', which stood at the junction of Duke Street and Friday Street, was auctioned. The lot was described as consisting of the build materials of 'Greyton House', and the freehold plot of the 1,270 square feet it occupied. The purchaser was legally bound to pull down the five-bedroomed dwelling within one month of sale, and construct a new build within eighteen months of November 1898. Only one dwelling house with additional shops or offices was to be built. Any activity that subsequently took place at the premises was to be of a non-noisy nature, with no offensive or noxious trade, and definitely no sale of alcohol. Thus, Oxford House was duly built, and by the early 1920s was the business address of the Wheeler Brothers. Their shop was primarily a general drapers that specialised in river wear. The Wheelers quickly expanded and leased Nos 1 and 3 Friday Street. The former Friday Street site of Wheelers (who still traded into the 1940s) is now the location of Auto Lex, and Oxford House is occupied by the Cook shop.

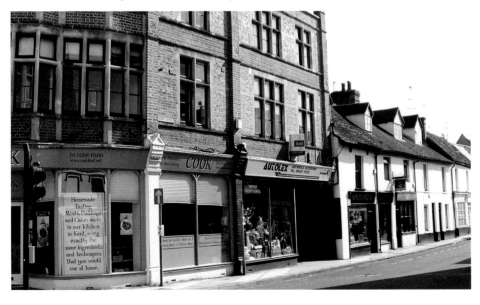

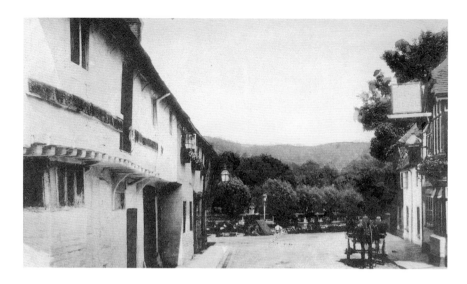

### The Granaries, Friday Street

Friday Street, which runs directly to the River Thames, was in existence by the 1400s, with a tenement in the street, known as 'Colynriggs' itemised in 1478. The area's name derived from the existence in the Middle Ages of a fishpond at its river end, supposedly only for the use of the Parish Priest. According to John Southerden Burn, in his book *A History of Henley-on-Thames*, Friday Street was populated by the town's poorest individuals in the mid-1800s. By the 1900s, Frederick Cresswell had moved from Newtown Gardens to No. 57 Friday Street. Like many men of restricted income, Frederick relocated frequently, and within nine years, he lived at No. 8 Reading Road and was employed as a Coal Porter. At the turn of the twentieth century, Friday Street had fallen somewhat into decline, and many of its houses stood vacant and neglected. Fortunately, the street is now recognised as a valuable historical asset, and its properties have been restored.

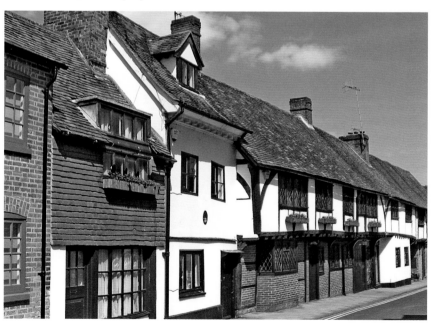

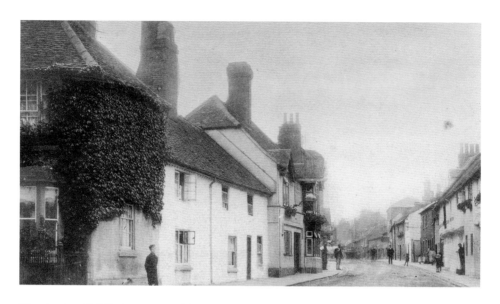

## The Anchor Public House & Baltic Cottage, Friday Street

In the 1850s, the Anchor was owned by Greys Brewery, but when the brewery was sold in 1896 to Brakspear's, it transferred to their ownership. Joseph Massie Furnival took over as Landlord of the Anchor in 1900. Furnival quit the Anchor in 1929, and died in Wokingham, aged seventy-eight, in 1936. The Anchor is, to this day, a popular drinking and dining establishment. Baltic Cottage was part of a mid-fifteenth-century, timber-framed Hall House, with a sixteenth-century cross-wing addition to its western end. In the nineteenth century it was extended, and by the 1890s was the home of John and Emily Agnes Chambers. John (born in Henley) was an 'Auctioneer, House and Estate Agent', his office situated at No. 15 Hart Street. He also acted as the Manager of the Gas Company, which was located at No. 62 Greys Road. From 1944 to 1966 Baltic Cottage was used as the ticket office for Henley Royal Regatta. In the 1970s, the house was divided into two properties, both of which are now private homes.

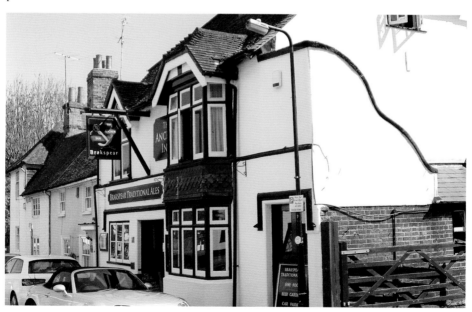

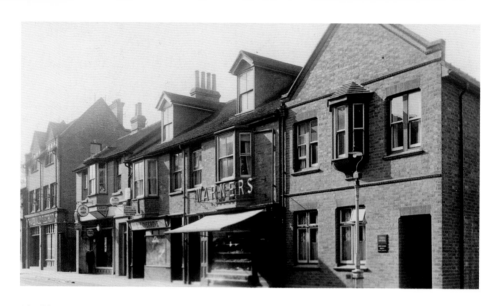

### Blackham, Warners & Lovegrove, Reading Road, 1940s

This row of commercial properties stands on the site of Southfield House, which was demolished some time in the early 1920s to make way for the Henley Post Office. George Blackham lived with his wife, Lilian, at 'Rippledean' on Vicarage Road, and practiced 'Dental Mechanics' out of the steeply roofed building pictured above. His unmarried son, Leslie, worked as a dentist alongside his father. Sadly, Leslie Blackham died aged only forty-eight, in 1958, at the Peppard Chest Hospital. Directly next door to the dental surgery can be clearly seen the projecting lettering of Warner's the Bakers. Alongside Warner's stood the premises of hairdresser, Leonard Noel Lovegrove. He served in the Queens Own Royal West Kent Regiment in the First World War, and married his sweetheart Elsie. Leonard never left his Reading Road address, where he died in the March of 1981. Blackham Dentistry is now occupied by Conway Solicitors; Warner's is the location of In the Groove Records and Lovegrove Hairdressers, is the site of the Mountain View Kitchen, a Nepalese restaurant.

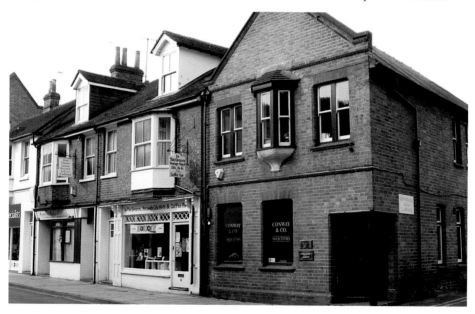

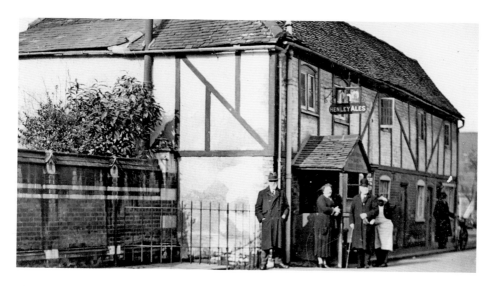

## The Three Horse Shoes Inn, Reading Road, 1920s

The Three Horse Shoes was an established hostelry before the 1800s, though it seemed not to have initially operated with a licence. Later, fully legal, it was under the ownership of Brakspears Brewery. On 28 November 1918, the Landlord of the Three Horse Shoes, Mr Herbert Ayres, died aged only thirty-two. His widow Bridget was able to take on the running of the pub. As the Three Horse Shoes protruded onto the main road into Henley, it was felt to be a hazard by the late 1920s. The inn and neighbouring cottages were thus demolished. Ernest T. Sheppard and Tomlins both now stand in its place. In 1898, Brakspears built a public house on the corner of Reading Road and Harpsden Road to cater for those who occupied the area's ever-expanding housing stock. The brewery's plan was thwarted, as repeated applications for a licence were refused. The building was therefore adapted for use as a grocers and sub-post office. In 1930, Brakspear's finally secured a license, and Bridget Ayres was relocated to run the newly named Three Horse Shoes.

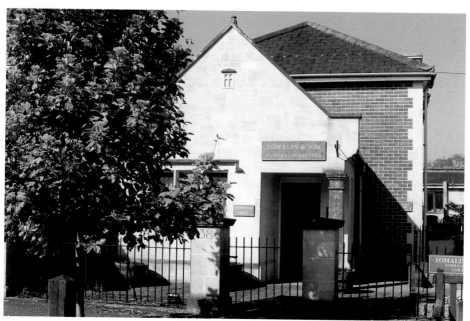

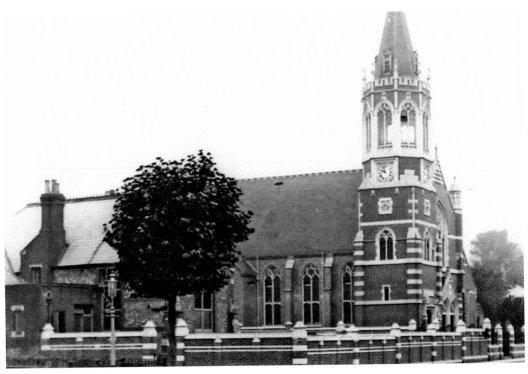

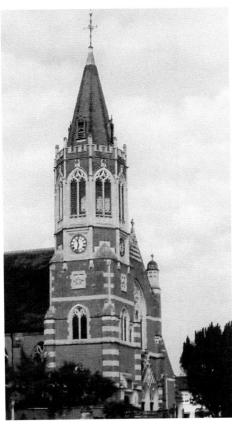

## Congregational Church, Reading Road

In the 1820s, the Independent Congregationalists met at their Meeting House on what is now the Reading Road. In 1829, the chapel was considerably enlarged by Pastor Robert Bolton, but by the 1850s a regular congregation of over 400 were squeezing into the building. A fund to raise money for the construction of a new church was launched by Pastor Sydney Tocker, and in 1907 a foundation stone was duly laid. The present Congregational church was completed in 1908, from the designs of Architect Hampden William Pratt, who had been responsible for the 1904 church hall. The new build, which could hold 500, was Gothic in style, and made a striking impression with its red-brick, yellow stone dressings and Art Nouveau glass. The cost of the adjoining tower was met by Frank Crisp of Friar Park, in memory of his Nonconformist grandfather, John Filby Childs. The earlier rectangular Meeting House (built 1719), which stood alongside the Reading Road, was demolished in 1909, its footprint the future site of a large, open garden. Towards the end of the twentieth century, the Congregational church was considerably altered, with the addition of infill buildings. The completed works opened as the Christ Church Centre in 2000.

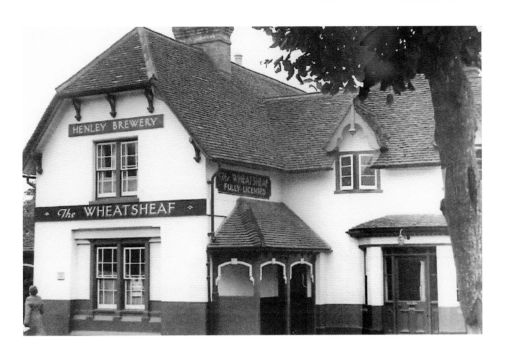

**The Wheatsheaf Inn, Reading Road, *c.* 1950**

A hostelry stood on this site from the latter years of the eighteenth century, at a time when the area was known as South Street. In the 1880s, it was so dramatically redesigned that it was, to all intents and purposes, a new build. The pub's appearance was conceived by the Architect and Surveyor Mr William Hambling. It is interesting to note that Landlord Herbert William Green also served as Post Master, the 1901 census marking him out of business. He died at No. 31 Gravel Hill, at the relatively young age of fifty-five, in 1907. Having for many years been one of the social hubs of Henley, the Wheatsheaf was demolished at the tail end of the twentieth century. A block of flats was subsequently built on its site.

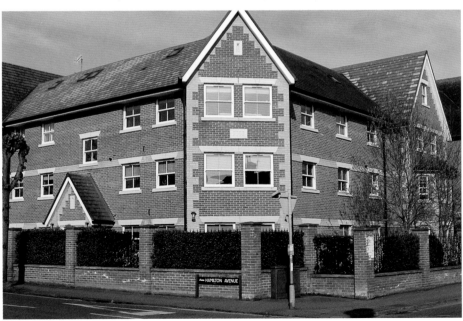

## No. 169, Reading Road

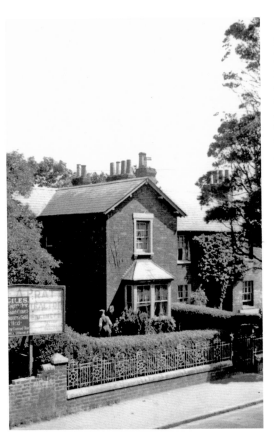

In the 1880s, there were a considerable number of terraced houses built towards the far end of the Reading Road, which were primarily geared towards the working classes. By the 1890s, terraced blocks built by the Hamiltons, such as Canadian Terrace and Montreal Terrace, were for the most part occupied by middle-class families. Further up the Reading Road, in Newtown, stood the small cottages of the families who relied on a man who earned his keep through an acquired trade or skill. No. 169 Reading Road, with its attractive railing and large tree, has an instant appeal. In the 1930s, it was the home of local builder Albert Broad, and it was for many years the home of Beatrice Robinson, who lived at No. 169 throughout the 1950s, and was still in residence in the late 1960s. On the above image, the signage board advertises H. G. Giles sand and cement. This alludes to a Humphrey G. Giles, who resided at No. 8 Farm Road. The row of whitewashed cottages, which have retained their charm and striking roadside tree, are privately owned.

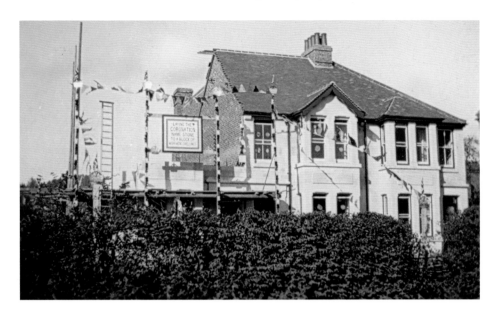

## Coronation Terrace, Reading Road, 1930s

Near the terraced row known as Prospect Place, on the Reading Road, was an area of land that had formerly been part of the New Town Nursery. It was here that the Wilsons chose to build a row of properties. The partially completed homes, pictured above, are adorned with bunting and a banner attached to the scaffolding announcing 'Laying the Coronation name stone to a block of workmen's dwellings'. The name of the properties was 'Coronation Terrace', chosen in recognition of the 1936 crowning of King George VI. The houses were quickly occupied and the main breadwinners' trades were, for the most part, locally based, such as housepainter Alfred Harry Neville, and engineer fitter Edwin Alfred Sainsbury. Coronation Terrace is, today, relatively unchanged, but the houses' market values are somewhat higher than when they were constructed.

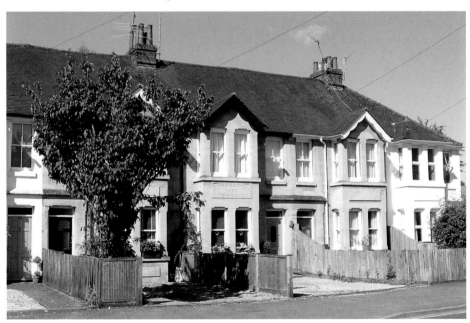

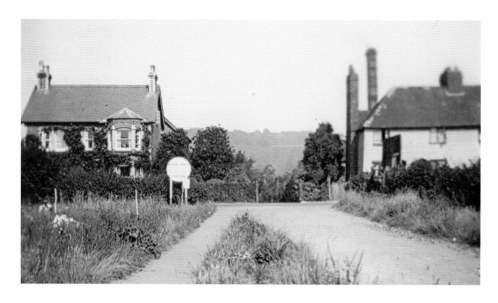

## New Town Nursery, Reading Road

Charles Burningham (employed as a Whitesmith) relocated from New Street to a premises on the Reading Road. The building, which is somewhat obscured by plant matter, became the business address of his new enterprise of market gardener. When Charles died in 1879, his widow, Eunice, took on the running of the New Town Market Garden. Her nephew James Gosden (who had lived with his uncle and aunt since childhood) acted as Manager. Mrs Burningham remained active in the company into her late eighties, dying aged eighty-seven in June 1912. On Wednesday 26 October 1927, the New Town Nursery grounds were placed in auction. Primarily advertised as available for building land, the lot included a brick stable, potting sheds and greenhouses. Confirmed bachelor James Gosden died aged seventy-two on 5 December 1930. What was the Burningham's home is now the Veterinary Centre, and the nursery's land is Wilson Avenue.

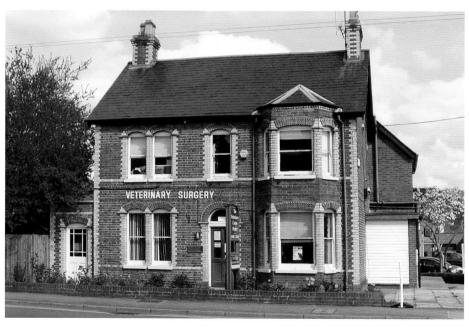

## The British School, Norman Avenue, 1890s

By the 1890s Frederick William Eagle was the School and Science Master of Henley's British School. His salary enabled Frederick and his wife, Edith, to take a fine town house at No. 60 St Andrews Road. William Robinson initially worked as a bricklayer in Battersea. By the 1890s, William had taken the position of the British School's Caretaker, with a sideline as a house painter. He and wife Mary Ann inhabited the neighbouring 'School Cottage', and shared their home with their boarder Alfred Clerk (a boat builder). The British School (the flint and brick building in the photograph) closed in 1932, and was later the site of Thames Carpets. It was subsequently demolished, and a block of flats sits on its former site. The elegantly dressed lady in the image is posing in front of an impressive detached property. In 1890, Henley developer Charles Clements built some uniquely styled homes in Norman Avenue. Henry John Williamdale Riggs resided at 'Torfridas' with his sister Charlotte. He is the same individual who worked out of Duke Street.

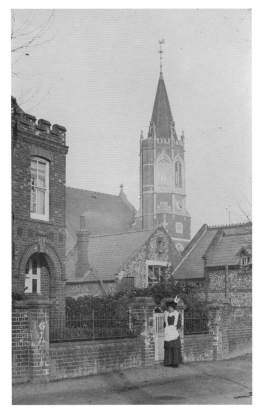

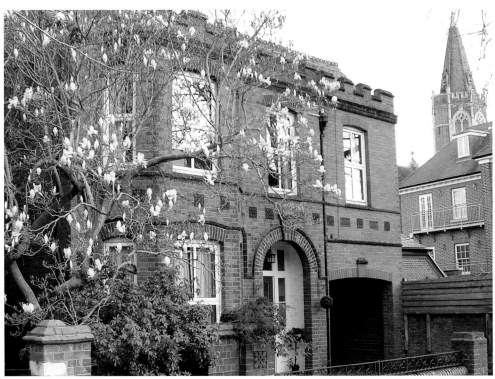

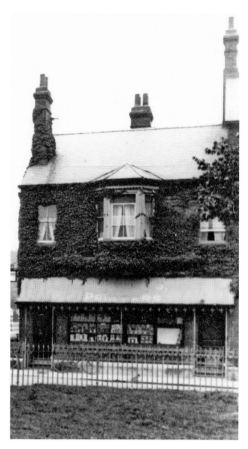

## Higgs & Co. Printers & Stationers (Caxton House), Station Road

In 1855, newly qualified printer Thomas Octavius Higgs relocated to Faringdon, and took up employment with Mr Lucker in the office of the *Faringdon Advertiser*. In 1874, Thomas's wife of fifteen years, Emily, died. The following year Higgs married Eliza Bridges, and in 1876 the couple moved to Henley. In 1877, Thomas set up Higgs & Co. (as a Printing Office) in Bell Street. In 1885, he built 'Caxton House', relocating his business, and in 1892 Higgs secured the contract to print the *Henley & South Oxfordshire Standard*. On Wednesday 7 October 1896, Thomas went, accompanied by his niece Miss Bridges, to collect a stair carpet he had purchased the previous Saturday, at 'Godiva', Norman Avenue. Having suffered heart problems, as soon as he attempted to lift his purchase Thomas collapsed. Doctor Browne was sent for, but Higgs died at the property. Thomas Octavius Higgs was buried in Faringdon, alongside his first wife. His widow sold Higgs, in 1897, to a partnership made up of members of the Hobbs family and a Charles Luker. 'Caxton House' remains the location of Higgs, as well as being the site of the Henley Standard's office.

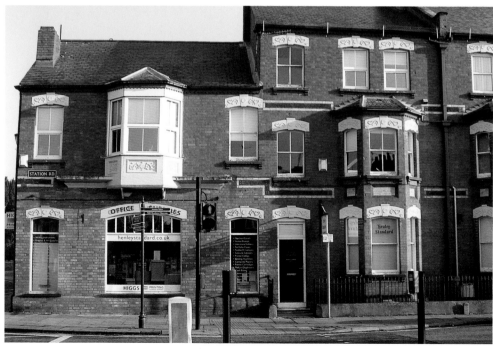

## The Convent, Station Road, 1890s

It is not certain what the original function of this structure was, but it is certainly memorable with its unusual tower. The premises was located among a cluster of trees, neighbouring the site of Searle & Sons, who traded as steam boat and electric launch builders, and the Royal Hotel, which was built by its original proprietor Robert Owthwaite. The above building stood just around the corner from the Catholic church of the Sacred Heart, and this may indicate why, from 1903, it was utilised as a convent school. This establishment was run by an order of Ursuline Nuns, and one of their most notable pupils was Eric Blair, better known as renowned author George Orwell. The nuns, while in occupation, are known to have rented outbuildings which were in the ownership of the Royal Hotel. The order had vacated the premises by the end of 1911, and the area in which the building stood was later leased to Thomas Rolfe of Station Garages. Although there may be no record of when the structure was demolished, the plot where it stood is now the site of a block of luxury flats.

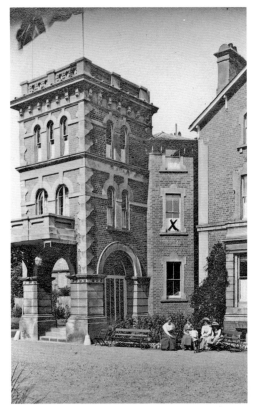

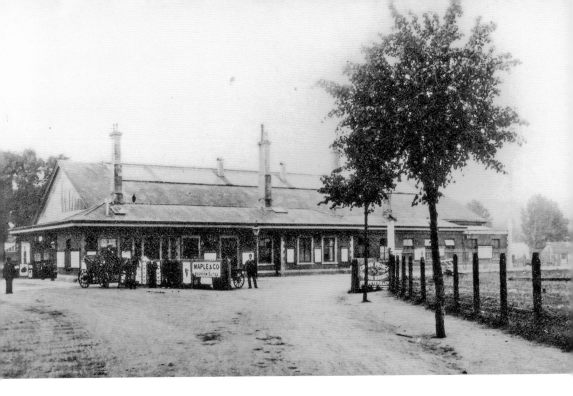

**Henley Railway Station, Station Road, 1900s**

Joseph Lock, born in Astley Cross, Worcestershire, had a lifelong connection with the railways. Having married in 1881, Joseph worked in London as a Railway Clerk. By the early 1890s, Lock took lodgings in Wycombe, where he was also employed as a Railway Clerk. Joseph's career advanced a pace, and by the 1890s he was Henley's Stationmaster, his home conventionally located just across the road at 'Oakhurst', Queen Street. Joseph and wife Martha, and their brood of eight children, later moved onto 'Hill View', St Andrews Road. By 1911 Lock had relocated to 'Hazelville' in Lower Shiplake, employed as a Station Master. Joseph Lock died aged seventy-six, on 20 December 1937. Martha, who at the time of her husband's death resided at No. 92 Westwood Road, Tilehurst, died aged eighty-nine in 1955.

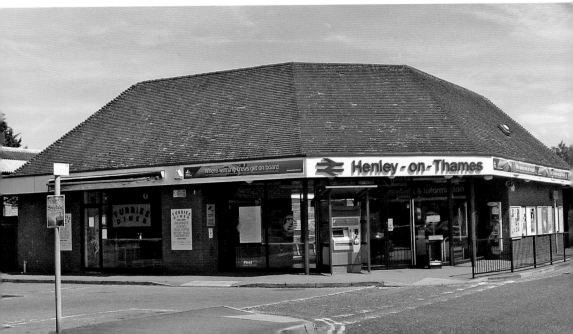

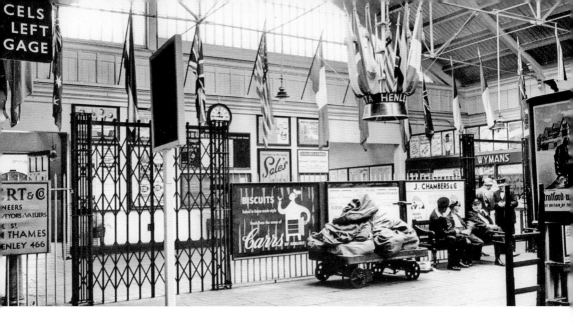

**Henley Railway Station Interior, Station Road, c. 1950**

Isambard Kingdom Brunel's Great Western Railway opened a branch line running down from Twyford to Henley-on-Thames on Monday 1 June 1857. The ambition was to have the line ready for the Henley Royal Regatta. *Virgo* (designed by Daniel Gooch, and built in 1841 by Rothwell & Co., Bolton) was the first steam locomotive assigned to Henley. A locomotive turntable and coal siding was situated in the middle of Station Road, which is now the landscaped area across from the present station. In 1876, the line was converted to single gauge, and by 1903 Station Road was widened, and the turntable replaced by a layout alongside the station's main building. During the 1960s, the track was reduced to a single line, and the last steam engine left Henley in the June of 1963, replaced by the less romantic diesel engines. In 1975, Henley station's building and its overall roof were demolished, leaving only the 1904 platform canopy. The railway is, today, a busy commuter line, though the present station's visual appearance is not easy on the eye.

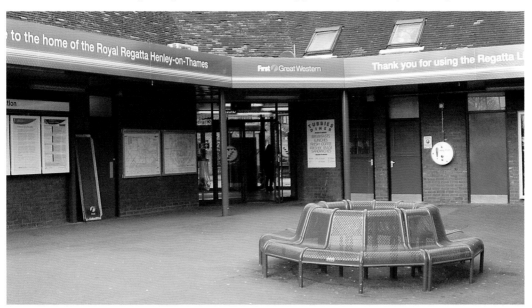

## Henley Railway Station Goods Yard, Station Road

The sons of Wargrave coal merchant John Toomer, William Henry and Robert, sold their Twyford based coal merchants in 1863, with the proviso that any purchaser had to buy their coal exclusively from the brothers. Richard traded from 'Gerrard House' in Reading, and later took 'Bridge House', No. 52 Hart Street, as a home. From the 1870s, a goods yard (built in gothic style splendour) had stood alongside Henley Station and Toomer Coal Wharf, with an adjoining siding stood close by. By the 1890s, Toomer & Co. Coal, Hay & Straw Factor Merchants, under Manager Mr J. R. G. Holloway, was flourishing. Robert Toomer died in 1892, but Toomer & Co. continued, and was still based at the station in the 1940s, with an additional yard in Friday Street. As an aside, the horse pictured standing patiently outside the station was under the care of Jimmy Jones. James Standish Jones (previously a cleaner at Reading Station) collected the post from Henley Station for many years. The Beeching Report of 1963 led to the removal of Henley's sidings, and the demolition of several storage buildings. The Goods Yard is now the site of a car park.

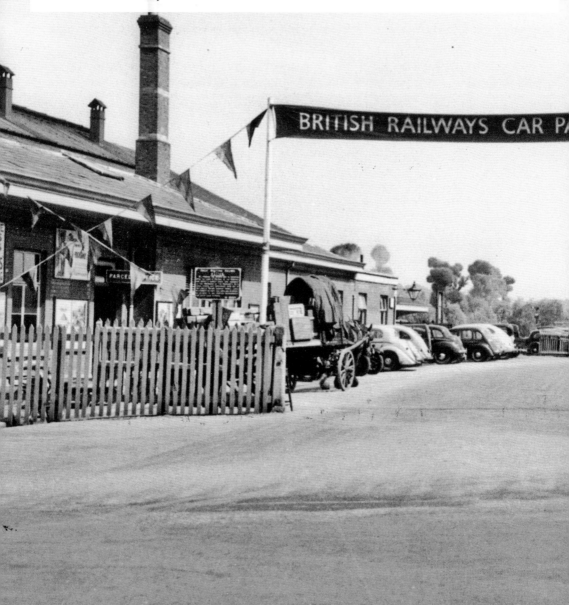

CAR PARK

ROWLAND

ESTATE AGENTS for
HENLEY on THAMES and DISTRICT.

FIRST
WITH
THE
NEWS
EVENING NEWS

GET
TO-N

RST
WITH

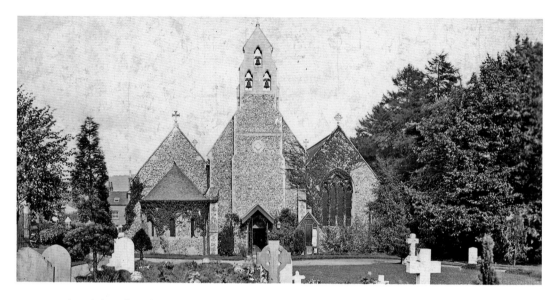

## Holy Trinity Church, Greys Hill

Due to the considerable increase in Henley's population, land was acquired from the Henley Corporation for the building of an additional church. Local man Benjamin Ferrey was selected as architect, and the foundation stone of Trinity church was laid by a Mr Baskerville on 25 May 1844, the build completed in 1848. By 1890, the church, which sat 500, was deemed too small, and after an appeal for funds it was enlarged by William T. Lowdell, at the cost of £4,500. Trinity's first Rector was William Phillip Pinckney, who was known affectionately as 'Topper', due to his habit of wearing a top hat while sculling on the river. A man with considerable income, he took no stipend (salary) for his first ten years as Rector. The Revd Pinckney (who resided at 'Normanstead', situated on Greys Hill) retired in 1888, and died aged eighty-eight, on 17 November 1898. He was buried in Trinity's churchyard.

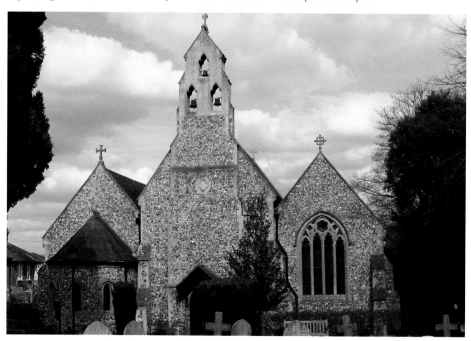

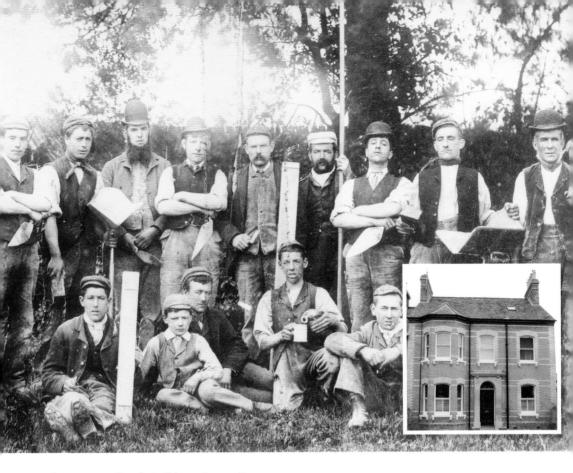

### Thomas Hamilton's Builders, Queen Street

Thomas and William grew up at The Row Barge in West Street, where their parents Thomas and Elizabeth Hamilton ran the inn primarily as a lodging house. Thomas senior (a builder) died in 1876, at his home in Duke Street, and from the late Victorian era his sons went on to become one of the dominant builders of houses in Henley. Thomas Hamilton, in the first years of married life, ran The Row Barge. He later built a selection of houses in Queen Street, and his family moved into No. 22, (*pictured inset*). Hamilton developed Kings Road with York and Clarence Roads leading off it. Thomas's wife, Eliza, died in 1920 aged seventy-eight, and was buried at Trinity church. Her son, Charles (a carpenter), who died aged forty-eight in September 1927, is buried alongside her. Thomas Hamilton died of bronchitis, aged eighty-five, on 14 February 1929, his funeral, held at Trinity church, was conducted by Revd Rawdon Willis. Hamilton's son Harry (a watch and jewellery maker) and four daughters inherited an estate of £30,555. Thomas Hamilton had a locally sourced building team, and the many houses they constructed are still standing.

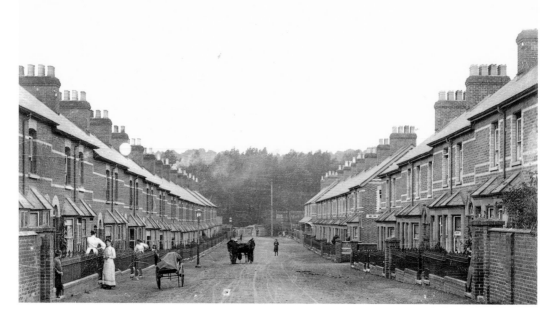

## Park Road, 1900s

Up until the mid-1890s, houses in Park Road only ran along the left-hand side, but in 1896 builder Thomas Hamilton laid out the remainder of the road, as well as Marmion Road. The build site was located near to his brother William's large-scale development on the Reading Road. Park Road, at the turn of the twentieth century, was an area very much populated by the working man. German born John Michael Schlotheur, a tailor and father of eleven, died aged sixty-seven on 30 April 1892, and his widow Kezia relocated from Middlesex to Henley. By 1900 (aged seventy) she ran a grocery provisions outlet from her home, No. 1 Park Road, assisted by her daughter Alice. Kezia Schlotheur died aged eighty-one, in the January of 1911. Alice later moved to No. 8 Western Avenue. She never married and passed away, aged eighty-seven, in November 1948. Park Road still retains its late-Victorian heritage, though the metal railings were sacrificed for the war effort, and the carts replaced with a multitude of cars.

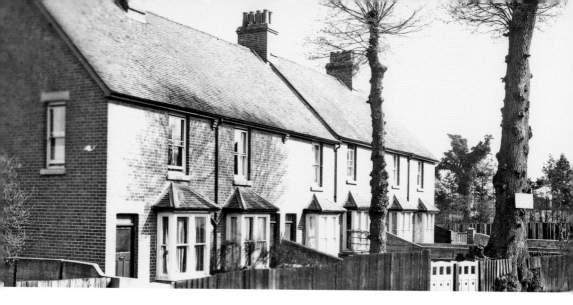

## Wilson Terrace, Harpsden Road

James Alfred Wilson, a builder's labourer, died unexpectedly, and his widow Ellen returned to her home town of Henley. When Ellen died (aged only thirty-five) in March 1870, her sons George, Thomas, Richard, and James, the eldest thirteen, the youngest just six, were duly admitted as 'Pauper Inmates' to the Henley Union Workhouse. By the late 1870s, George Wilson was a lodger at the Duke Street residence of Caroline Pigden. By the 1880s, George (employed as a bricklayer) was a boarder at No. 90 Church Street, the home of one Apollas Morris. George married Mary Jane in 1891, and things went well for this enterprising man. He and his brother Richard started to build houses, in roads such as St Marks, St Andrews and Vicarage Road. Now comfortably off, Wilson moved his wife Mary Jane and family into a Wilson build, 'Mervyn' on St Marks Road. George Wilson retired aged sixty-eight and died aged eighty-three, a widower of twenty years, at his home on Sunday 5 May 1940.

## Wilson Avenue, During Construction in the Early 1930s

Upon leaving Henley Workhouse, Richard Wilson lodged at the Row Barge, and no doubt while there met his future wife Annie, the owner Thomas Hamilton's daughter. Annie's marriage in January 1889, to a workhouse boy, caused an estrangement in the Hamilton household, and the newlyweds lived for some time in Albert Road. Richard Wilson became a very successful builder, and eventually was welcomed by the Hamiltons. He moved to 'Malvern' in Queen Street, directly nextdoor to his father-in-law Thomas. Later Richard and Annie relocated to 'Hillston' a property the Wilsons had recently built on St Marks Road. In the 1930s Richard built Wilson Avenue on the former site of New Town Nursery, and during the Second World War some of the properties were commandeered for evacuees. Retired Town Councillor Richard Wilson, elected Mayor in 1917, died aged seventy-six on Monday 1 April 1940.

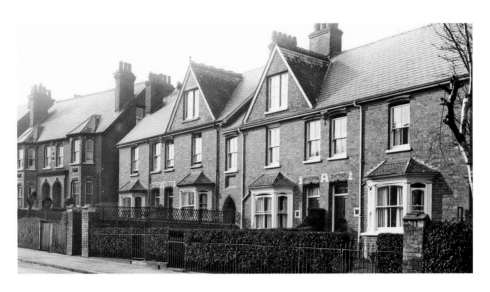

### Vicarage Road, 1910s

In 1899, only thirteen houses stood on Vicarage Road, for the most part occupied by families with a good standard of living. No. 2 Norfolk Villas was in the possession of the Methodist Wesleyan Chapel (which stood on Duke Street, demolished 1983) and was used as a residence for their Ministers. At the turn of the twentieth century, the Chapel Minister was former tutor Arthur Thomas Burbridge. His time in Vicarage Road was relatively short, and within ten years Burbridge had relocated to a ministry in Bristol. On Thursday 27 February 1902, Simmons & Sons auctioned off sections of the St Marks Estate. Lot eight was a freehold plot of building land, with a frontage of 60 feet onto Vicarage Road, and some 176 feet to its rear. The plot on offer was the site of brick and tiled stables (occupied by a herd of cows) and a coach house, with servants' loft accommodation above. The gradual release in the early twentieth century of building plots rapidly altered Vicarage Road's appearance, and by 1910 the road had twenty-eight properties. Today it contains an eclectic mix of architectural styles, though sadly some of Vicarage Road's very fine villa houses were demolished in the early 1970s.

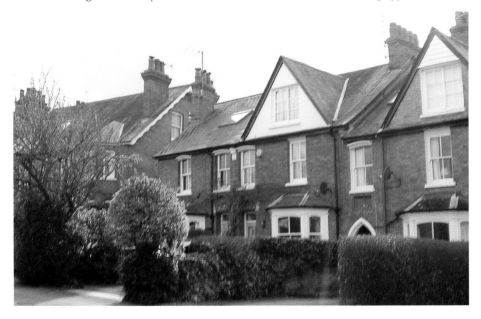

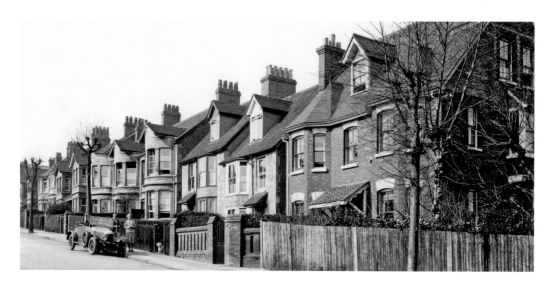

### St Andrews Road

In 1899, there were twelve homes on St Andrews Road, consisting of fine villa-style residences for the upper-middle classes. Arthur Richard Lloyds lived at 'The Acacias', St Andrews Road, and his profession as Clerk to the Local Public Authorities afforded him a good lifestyle. He worked out of an office, alongside Henley's Post Office, on the Reading Road, and his professional role was varied indeed. Arthur acted as Clerk to the Workhouse Guardians, The Assessment and School Attendance Committee, The Burial Board and Smiths Isolation Hospital; and he was also Superintendent Registrar of the Henley Union. What little family time his busy working life afforded him, Arthur spent with his wife Mary, and their two sons. Arthur Lloyds died suddenly, aged seventy-three, on 29 June 1934 in Victoria, Australia. His body was repatriated, and Arthur was laid to rest in Trinity churchyard. Mary never left The Acacias, and died there in 1946. In July 1902, further building plots were sold on St Andrews Road, and as such it contains several fine Edwardian homes.

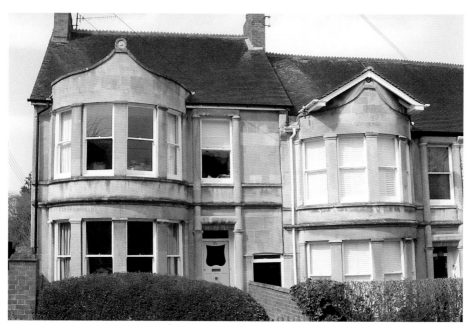

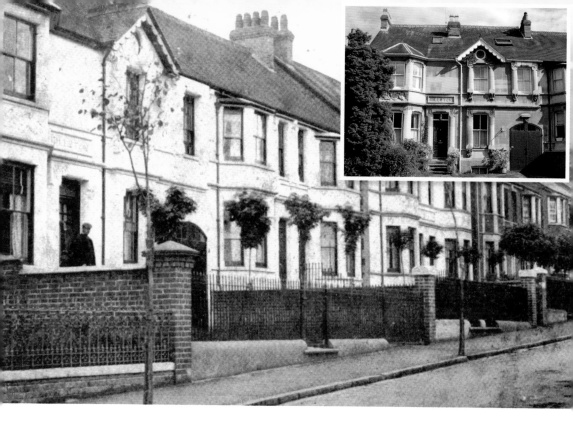

## St Marks Road

Landowner and builder Robert Owthwaite, purchased 104 acres of land west of the Reading Road in 1850, but the land was not developed in his lifetime. When he died, aged eighty-three, in 1887, his properties and lands were sold by order of his trustees. The auctioneer, Mr V. T. Hews (situated at No. 15 Hart Street), hired the Catherine Wheel Hotel, and the auctions took place on 12 July and 20 September 1888. The eleven lots, which included the St Marks Estate, were sold off to individual builders, though any future developments on St Marks had to abide by certain restrictions. No house or tenement erected was to be used as a school, asylum or hospital, or for any trade or business, or for the sale of beer, wine or spirits. No gypsies, tramps, vagrants or thieves should at any time be harboured or allowed to squat of any portion of land. No gravel, sand or clay was to be excavated without permission and license of Robert Owthwaites trustees. By 1901 St Marks had twenty-one houses, and later several Art Nouveau style villas, many with stone carvings and dressings, were built by Richard and George Wilson.

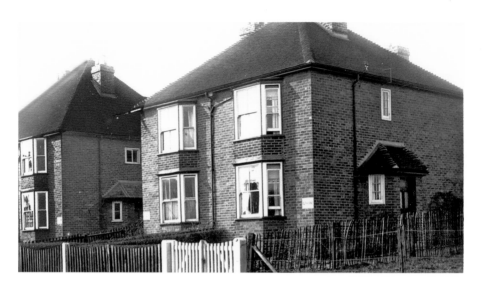

### Wilson Houses, Berkshire Road

On Thursday 2 May 1895, the agents for vendors, the late Robert Arthur Owthwaites trustees, and Henry Ramsay Taylor, sold in auction the seventh portion of St Marks Estate. The auctioneers were Baker & Sons (located at No. 11 Queen Victoria Street, Reading), and the ninety-seven plots went under the hammer at the Red Lion Hotel in Henley. Primarily building land, the plots, which were located on an elevated position with frontage onto St Andrews and Berkshire Road, were sold free of Tithe and Land Tax. On Thursday 26 May 1904, Simmons & Sons auctioned another portion of St Marks Estate, which included plots on Berkshire Road (the site of a Gravel Pit) and eight plots on Belle Vue Road. It was specified by the vendors that the area had an excellent gravel subsoil, and was suitable for good-class residences, with ample provision for generous gardens. The water and sewerage mains had already been laid in several adjoining roads, and this, it was pointed out, could only be advantageous. The two pairs of semi-detached properties (*pictured*) were the first four homes built by local builders the Wilsons on Berkshire Road. They also built houses in nearby Belle Vue Road. The four houses are still standing, though they are somewhat altered externally.

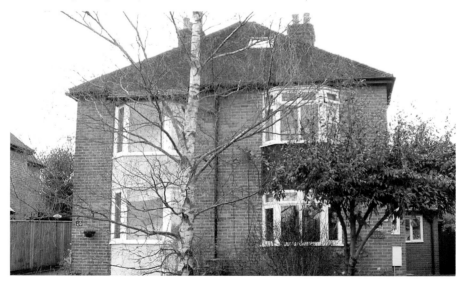

**Gillotts House, Gillotts Lane, c. 1947**

Gillotts (also known as Gilletts) grew out of what was a small Elizabethan house with surrounding farmland. By the 1600s the estate was held by farmer Henry Round, and by the 1790s Gillotts consisted of 40 acres. William Hodges of Bolney Court held the estate in the 1830s and let it to John Sedgwick. Gillotts passed down to John Fowden Hodges who, in the 1850s, put in tenant Joseph Henry Wilson, a Barrister. Edward Mackenzie of Fawley Court subsequently purchased the estate and transformed the main manor, with extensive remodelling and landscaping of the grounds. His eldest son, William Dalziel Mackenzie, made Gillotts his home. When Edward Mackenzie died in 1880, he settled Gillotts on his fourth son, Keith Roland Mackenzie, with the proviso that Edward's widow Ellen could reside at the manor. In 1919, Commander Robert Corbett Bayldon purchased Gillotts, and the house was much altered, which included the addition of a Loggia (covered gallery) and replacement 'mullioned' windows. During the Second World War, Gillotts was utilised as a convalescent home for soldiers, Commander Bayldon relocated to Gillotts Lodge. In 1950, the site opened as Gillotts, a girls only Technical School, under Headmistress Miss Barford. In the early 1960s, part of the house was demolished, which revealed in the process the shallow foundations of the Tudor farmhouse. The girls' school closed in 1960, and Gillotts became the location of Henley's Secondary Modern, which had relocated from its Gravel Hill site.

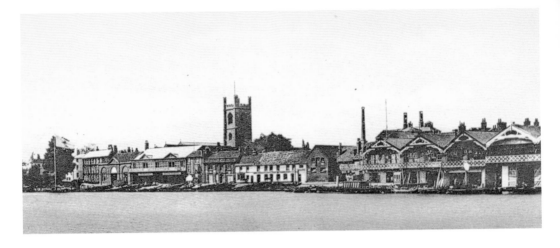

## Hobbs Boat Yard, Thames Side

Towards the late nineteenth century, goods were moved more frequently by road, which led to a decline in Henley's riverside wharfs. In 1870, Henry Edward Hobbs took over one such wharf located in Wharf Lane, and operated it as a boat builder's yard. Henry had worked as a carpenter and from 1871 owned The Ship Hotel in Wharf Lane. The company grew and Henry and his wife Emily's six sons – William, Arthur, Frank, Ernest, Frederick, and Albert – worked alongside their father. The Ship closed in 1897, and in 1898 the company relocated to premises at the bottom of Station Road. In 1902, Hobbs & Sons registered at a Limited Company. Emily died in 1907, aged sixty-six, and her widower Henry died aged sixty-eight on 7 January 1910, at 'Belmont House', New Street. His sons carried on the company, including Arthur Hobbs, who was employed as a skipper, boat builder and company secretary. He was married to Edith, and the couple lived at 'The Cottage', No. 22 St Marks Road. Arthur later went on to hold 'Moulsford Manor', Moulsford in Berkshire. He died, aged eighty, at Thames Bank Nursing Home, Goring, on 28 February 1950. Henry Hobbs' great-great-grandson Jonathan is the present head of the company, and the Hobbs' former Wharf Lane Boat Houses were converted into high-end flats.

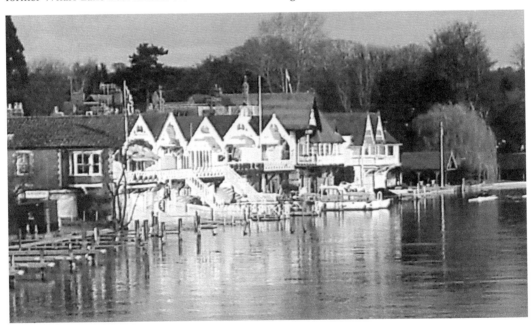

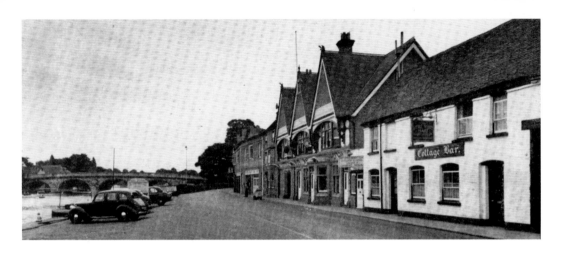

### White Hart, Thames Side, 1930s

The Little White Hart (built in the eighteenth century) was put up for sale in April 1832, described in the sales catalogue as a public house with a granary cottage and coal yard. Brakspear's Brewery, which subsequently brought it, altered the pub's frontage. From 1884 the Landlord was Henley born William Clisby. When Clisby retired in 1901, he initially lived at No. 35 New Street, but it seems a sedentary life did not suit him, and by 1911 he was proprietor of the Kings Arms Hotel, London Road, Twyford. William died, still in occupation, aged sixty-nine on 18 April 1912. The Royal Jubilee Lodge (later incorporated into the Little White Hart), seems to have at one time been a private residence. By 1899 it was occupied by spinsters Mary and Agnes Harriet Johnson. These two women were the daughters of Edward and Elizabeth Johnson, both of whom had run the Angel Hotel. The women had inherited a share of £2,400 from their parents, and thus were financially secure. Mary died aged seventy-five, at No. 87 Reading Road, in the August of 1921; her sister Agnes died at No. 36 Queen Street, aged eighty-nine, in July 1945. The Little White Hart is now closed, and its former premises are occupied by the Spice Merchant Restaurant, and the Royal Jubilee Lodge is a branch of Jaeger.

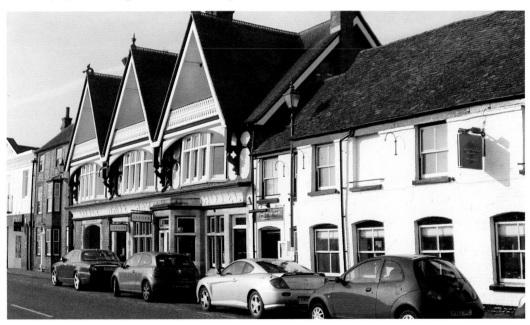

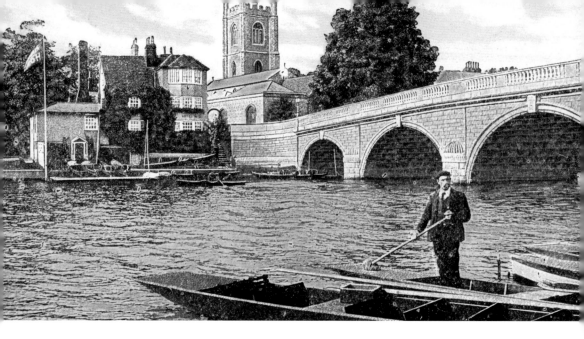

## Henley Bridge, Thames Side

By the closing decades of the eighteenth century, it was universally agreed that Henley's wooden bridge was in a deplorable state. Indeed it so outraged Sambrooke Freeman, of Fawley Court, that in 1769, he arranged for it to be covered with boards so it would match the appearance of the bridges in Florence. After much wrangling, the Henley Corporation advertised for plans for a new bridge, and in June 1781 William Hayward's design was approved. His contract price was £9,727, and the money was raised by loans. William was not destined to see his plans come to fruition; he died of a fever, aged forty-one, on 16 January 1782, before construction commenced, and desired to be buried in the bridge's foundations. John Townesend was commissioned to take over and, and following his death in 1784, his son Stephen finished the project. Henley Bridge was completed in 1786, and a Toll Bar, on the Berkshire side of the River Thames, remained until 1873, when the loans raised for the bridge were finally paid off. Hayward's bridge still serves Henley, and William, who was not granted his last request, was buried in the parish church of St Mary's, and is commemorated by a plaque.

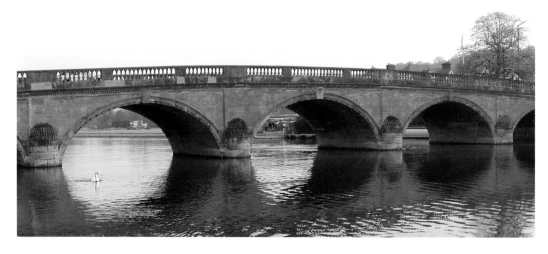

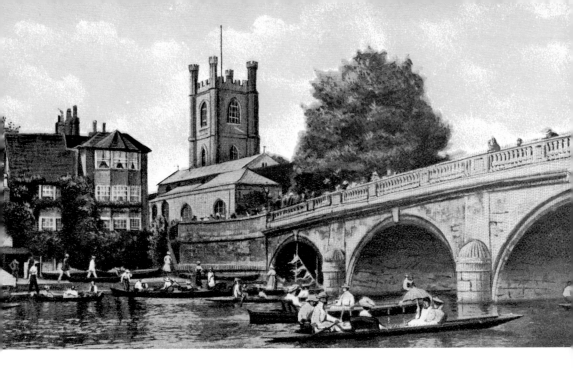

### Angel Hotel, Thames Side

The Angel is a building that incorporates aspects that date from the late sixteenth century, at one stage having been a residential property. Thomas Fox Alexander Byles ran Greys Brewery out of premises close to the Anchor pub, in Friday Street, and the Angel Hotel was one of the fifty-four public houses the company owned. In 1897, the Greys Brewery and its stock of pubs were sold to Brakspears Brewery. The purchasers quickly closed down Greys Brewery, which was, with the exception of a small area, later demolished. At the turn of the twentieth century the Angel Hotel was under Landlord Richard Clement Court. By the next year, Richard and his wife, Annie, had moved on to running the Crown Hotel in Alton, Hants. Richard died, aged thirty, on 13 March 1902 at Holloway Sanatorium, Virginia Water. The hostelry, now known as The Angel on the Bridge, is still a vibrant public house.

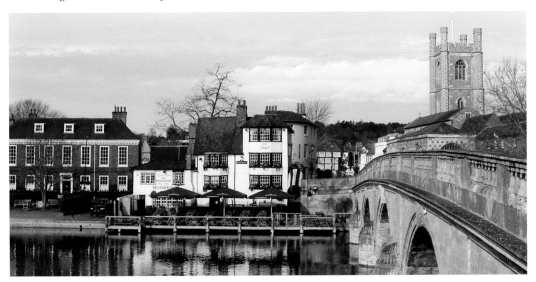

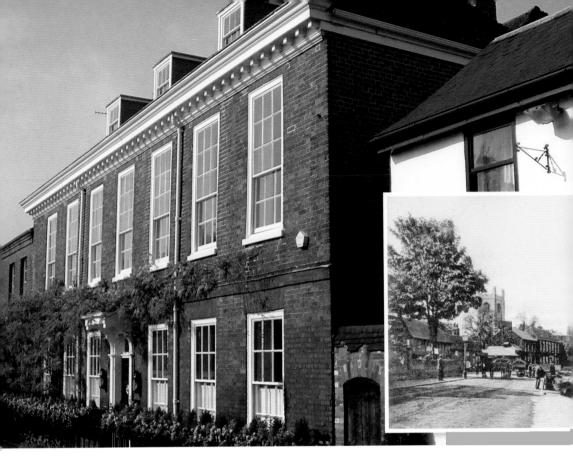

### The Rectory, Thames Side

The Rectory is an impressive seven-bay structure, with a later grey and red-brick façade , the dates 1701 and 1715 scratched on its brickwork. When William Brooks (owner of The Bear Tavern, and a Malthouse and brewery in Bell Street) died in 1744, he left his son James extremely well off. In 1750, James Brooks enlarged the brewery business, acquiring a Malthouse, granary cottage, and several taverns, The Bull, White Horse and Star. As befitting his status, Brooks purchased the fine riverside premises described above. In 1762 James dispensed with Mary, his wife of fourteen years, paying her a severance sum of £1,200. He duly set up home with his mistress at 'Bowling Green Farmhouse', on the south-west end of the Fairmile. James Brooks' personnel life became one of contentment, and the couple had four girls and one boy. In September 1768, Brooks took in Richard Hayward as a brewery partner. By 1770, with over 100 acres of land in Greys, Peppard and Henley, Brooks was one of the area's richest individuals. James Brooks died aged seventy-nine in 1803, and on 18 June he was interred at St Mary's. His former home at Thames Side was acquired in 1826 by James King, Rector of Henley's parish church, for use as a manse. After some 153 years, St Mary's manse was relocated, and the property was sold in 1979. It is now in private ownership.

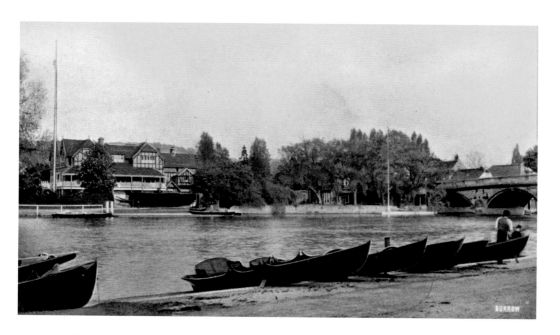

## Leander Rowing Club, Thames Riverside

The Leander Rowing Club was founded on the Tideway in 1818. It relocated in 1831 to Putney, where in 1866 the club's first boathouse was built. No doubt attracted to Henley by the town's yearly rowing event, the Henley Royal Regatta (in which, from its conception, Leander had much success), the Leander Club chose to base themselves in the town. In 1896, Henley Town Council leased to the rowing club a plot of land alongside Henley Bridge, on the Berkshire Bank. Rental per annum was agreed at £25, and Leander was required to spend £2,500 on the build cost of a residential structure with a boathouse. The council's deadline for construction of no later than 24 June 1898 was met. In 1908, the Olympic Games' rowing events took place at Henley, and Leander secured their first Olympic Medal. Over its long history the Leander Club has nurtured and trained rowers of the highest calibre, Sir Steve Redgrave among them.

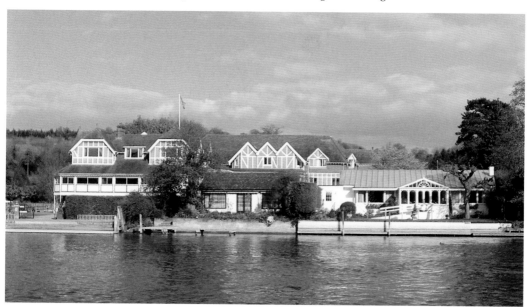

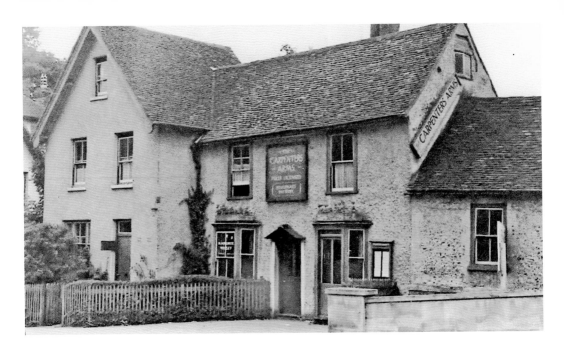

### The Carpenters Arms, Remenham

The hostelry, whose original structure can be dated from the early 1700s, stood on the Remenham side of Henley Bridge, overlooking the Thames, gradually enlarging into two adjoining properties. It was, for fifty years, under the Landlordship of one family, the Pigdens. William Pigden ran the Carpenters from 1850, until his death in April 1863, aged forty-four. His widow Sarah took over, having inherited under £50. She died November 1867, aged forty eight. Two of the couple's six daughters remained at the pub; Sarah Ann was Landlady until her death, aged fifty-two, in the December of 1899. Her sister Mary (who ran the Carpenters until June 1900) enjoyed a somewhat longer life. She died aged seventy-seven on 24 September 1935, at her home 'Trovato', No. 12 Cromwell Road. The Pigdens were laid to rest at St Nicholas churchyard Remenham. The Carpenters Arms closed its doors in the September of 1973, later to be demolished. Henley Royal Regatta Headquarters, designed by Terry Farrell, and officially opened by her Majesty the Queen in April 1986, is in its place.

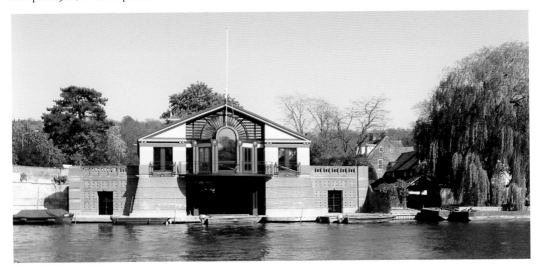

### Little Angel, White Hill, Remenham

This structure is a much altered eighteenth-century brick and flint building. Until 1853 it was in the ownership of William Peere William Freeman of Fawley Court Estate, and was included in an auction of his estate holdings. The hostelry was subsequently owned by J. Pitman & Pitman's Brewery, later purchased by W. H. Brakspear & Son Ltd. Charles Butler (a brick layer) was Landlord from 1864; he retired in 1896, and died two years later aged eighty-seven. His daughter, Martha, had married Edgar Butler, and he took over from her father, acting as Landlord until his death in 1913. His widow, Martha, ran the Angel Inn until her death, aged ninety-one, in 1939. Her son, Edmund Frank Butler (a builder and carpenter), held the Angel's licence until his death in 1950. His widow Ann Martha vacated the Angel Inn within one year. The Little Angel is today a popular public house and eatery.

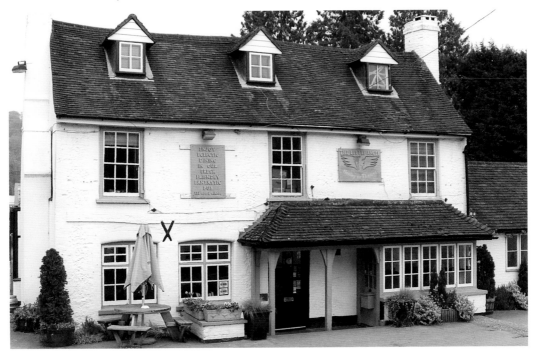

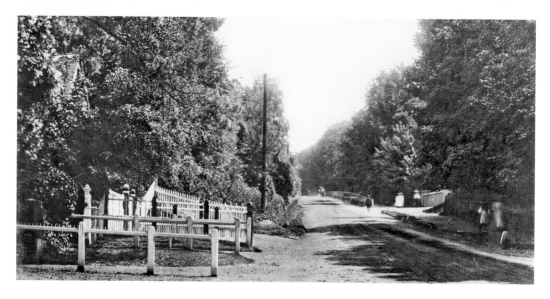

## White Hill, Remenham

Skilled engineer Humphrey Gainsborough (Minister of the Independent Congregationalists Chapel), was commissioned in 1768 by General Henry Seymour Conway of Park Place to superintend the works to moderate the steepest section of White Hill. This feat was achieved by cutting away the top of White Hill; the excess soil was then placed into carts attached to a chain, which when pulled sent an empty cart up to the top of the hill. The removed soil was placed at the bottom of White Hill to form a causeway below. Later Gainsborough took on the responsibility of collecting the lock tolls between Sonning and Hambledon. On 23 August 1776, Humphrey failed to arrive at a prearranged dinner; the other guests grew alarmed regarding his whereabouts and set off to locate him. They discovered Humphrey lying dead in Lion Meadow, with £70 of toll money in his pocket. As Humphrey (a widower) died childless, his brother, the renowned artist Thomas Gainsborough, administered his estate. White Hill is still one of the major thoroughfares to and from the town, and thanks to Humphrey's excellent efforts it presents a less daunting descent into Henley.

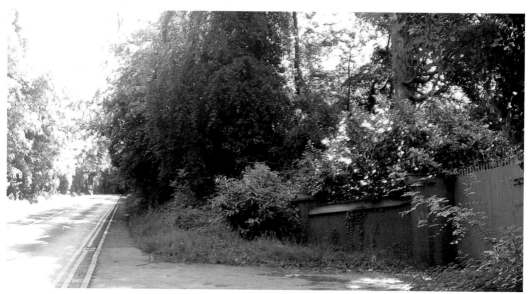

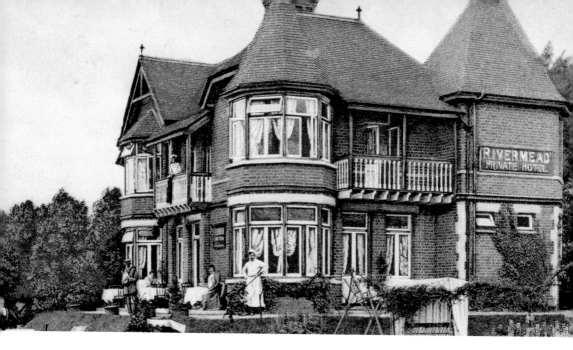

## Rivermead, Thames Side

Louisa Gohegan arrived in Henley recently widowed, previously having run a lodging house at No. 3 Cavendish Place, Brighton, with her husband Arthur Richard Gohegan. Arthur had died on 29 October 1898, aged forty-six, at Upper Avenue Road Hampstead, Middlesex, leaving Louisa in need of an income. By the turn of the twentieth century, this enterprising woman secured employment as Manageress of the Red Lion Hotel, Hart Street, moving on to the position of keeper of an elegant riverside establishment, the Rivermead Private Hotel, assisted by maid Ellen Miller. Louisa Gohegan seems to have made a success of her venture, living to ninety-seven and still in ownership. She passed away in the November of 1950, at No. 7 St Andrews Road. Louisa's estate was handled by local Solicitors Collins Dryland & Thorowgood, and probate was granted to her trustees, the capital left nearing the £3,000 mark. Rivermead still stands, having been extended and subdivided into three separate homes.

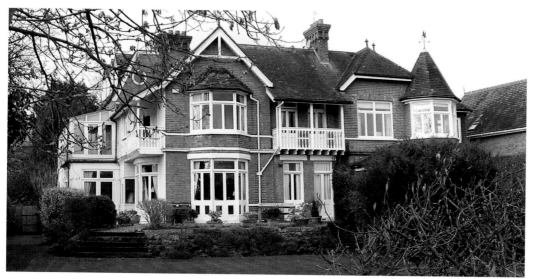

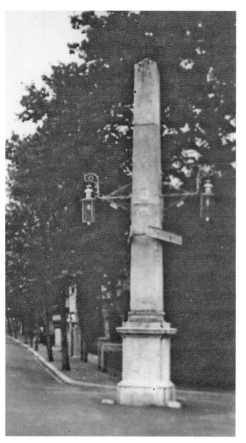

## The Obelisk, Riverside Promenade

The Obelisk, which dates from around 1788, was made from Portland Stone. It was placed at the Market Place and Hart Street crossing to commemorate the demolition of Middle Row (to allow an improved approach to the recently completed Henley Bridge), which ran up the centre of the high street. At a later stage, a pump was located close to the Obelisk to draw water from a well, which allowed Market Place and Hart Street to be washed down. The Obelisk was inscribed with the distances to Reading, Oxford and London, and later had street lamps attached. In 1880, due to increased traffic through the centre of Henley, and the positioning of the Phillimore Memorial Fountain in Market Place (the fountain now located close to St Mary's church in Hart Street), the Obelisk was relocated to Northfield End, positioned at the junction of the Marlow Road, the site shown in the photograph. In 1970, the Obelisk was again moved, and for some time it lay dismantled, on its side, and somewhat neglected. In 1973, its historical legacy acknowledged, the Obelisk was relocated to the town's riverside promenade, where it still stands, a resplendent acknowledgement to Henley's Georgian age.

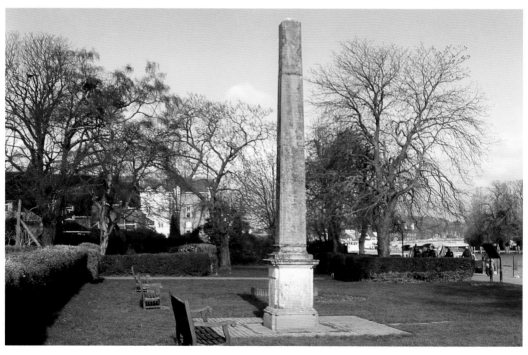

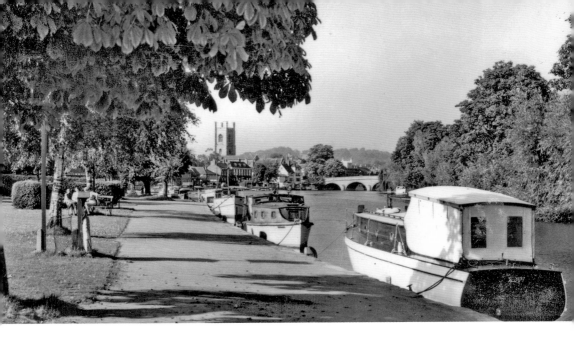

### The Promenade, Riverside

In the eighteenth century, the Thames had primarily been used for river trade, but by the early nineteenth century many turned to boating as a leisure activity. This led to friction between river workers and leisure boaters. In 1804, the Bye Law Commissioner stated that all barges had to be registered, and that gentlemen using the river for pleasure were not to be threatened, obstructed or sworn at by bargemen or their crew, a fine of £10 to be levied for each offence. By the 1870s there was a sharp reduction in river trade, and Henley's riverside became a haven for Londoners, many of whom took advantage of the railway's speedy journey times. In 1921, Henley Council purchased Mill Meadows for the sum of £2,800, and the following year excavated a lake, constructing two crossing bridges over it. In 1924, a grass tennis court and bowling green were opened. The scenic lake had become anything but, as it was mostly concealed under a mass of algae and weeds. Ducks were introduced into the lake in 1933 to help remedy the problem, but it seems the idea failed miserably, and in 1939 the lake was filled in. Marsh Meadows was purchased by the town in 1966, and Henley's river frontage is still a popular location for locals and visitors alike.

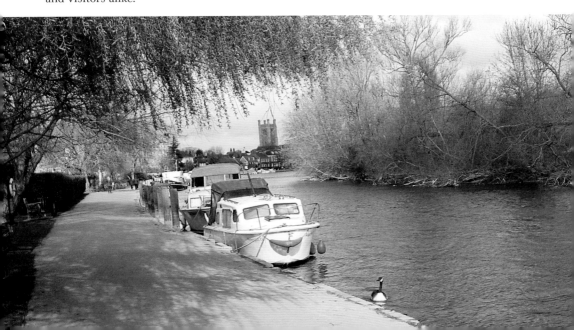

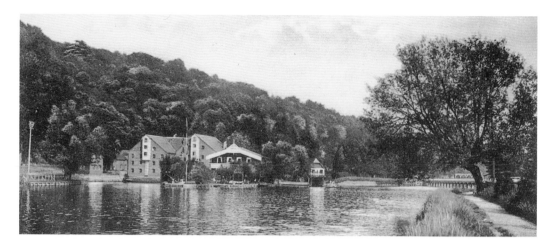

## Marsh Mills, Riverside

By the 1850s, William Vidler (married to Elizabeth), who lived at Marsh Mills (producing flour), had secured his position as one of the principal dealers of corn in the area. He farmed 210 acres, employing fifteen men. When Vidler died aged sixty-six, on 12 April 1895, his effects were valued at well over £1 million, in today's money. William was buried at Remenham, alongside his wife, who had died the previous November. Marsh Mills Estate was auctioned by Simmons & Sons on 16 July 1895. The mill was described in the catalogue as working on a combined system with seven pair stones, two pair 'Meddling Rolls' and two waterwheels of 60 horse power. It was lit by electricity, and fitted throughout with Hopkinson's patent machinery. It was also stated that the mill provided stabling, cow houses, a piggery and entrance lodge, suitable for a site foreman. In the 1920s, Marsh Mill was run by Samuel Kidd & Co., and by the late 1930s by Wallis & Son & Wells. By the 1960s, Marsh Mills had fallen into disrepair, and was later demolished and replaced with flats.

## Mill Lane

Mill Lane was so called as it ran down to the river edge and thus onto the two watermills, which nestled on either side of the Thames. New Mills stood on the Henley side and was itemised in the Bishops List of 1585, and included in Overton's Map of 1715. One-time owner J. T. Wells unsuccessfully tried to sell the mill in 1883, at a price of £8,000. Charles Henry Smith was a 'Stationer and Paper Bag Maker', who lived at 'Bath Place', Reading Road, with his wife Sarah, who manufactured umbrellas. By the 1900s, the family had moved to No. 4 River Terrace. One of his two stepsons, Frederick Bendy, was Manager of the company's factory at No. 35 Friday Street, while the couple's son Ernest Edwin Smith was Manager of New Mills (a papermill), which his father had acquired. Charles died on 24 June 1913, leaving his family over £4,000, and his business in good hands. Ernest Smith died at No. 4 River Terrace, aged seventy, on 23 November 1940, and probate was granted to his unmarried sister Agnes. Some of New Mills was retained, with housing on the site, while the factory in Friday Street (pictured below Marsh Mills), is at present unoccupied. Mill Lane is still a popular thoroughfare, to the River Thames and promenade.

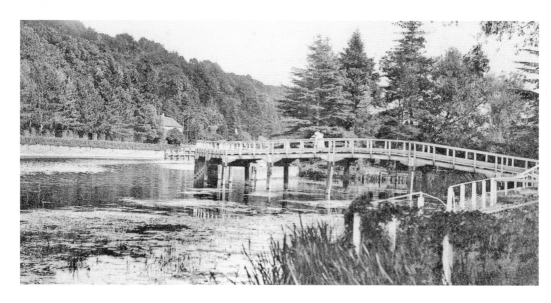

## Wooden Bridge, Marsh Lock

The wooden bridge, which runs up to and beyond Marsh Lock, was constructed around 1770, primarily to provide an alternative route for the horses that towed commercial river barges, the area around Marsh Lock being obstructed by small islands, buildings and the like. At the turn of the nineteenth century, larger horses became available, and since they were able to pull heavy barges, the use of men, who had previously filled the role, decreased sharply. The loss of jobs among men who, in many cases, belonged to generational families of barge workers, led to much disquiet. Riots broke out in towns in and around the Thames Valley, with much damage done. The day's mayhem often ended with the bargemen going on pub crawls. After the 1860s, with the increase of the conveyance of goods by rail, the river trade declined, and by the latter years of the nineteenth century the wooden bridge was less frequently used. As such, in the 1880s, the structure was under threat, but common sense prevailed, and although the heavy horses are long gone, this charming little bridge is frequented by locals and visitors alike, as they wander up river, taking in the beauty and serenity of the Thames.

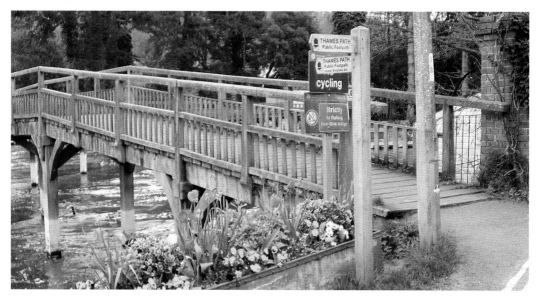

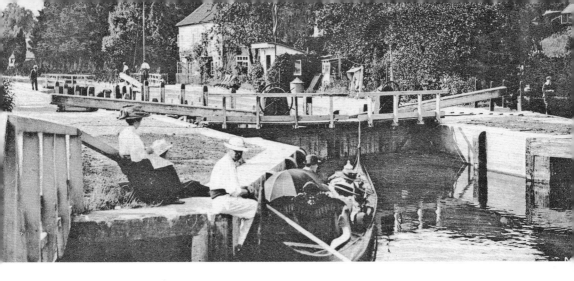

## Marsh Lock, Thames Riverside

In 1773, a Pound Lock (a construction with gates at each end, within which water levels can be raised or lowered) was built at Marsh Lock. The first keeper was John Ward, but by 1780 the lock was already in a state of poor repair and thus rebuilt in 1787. A 'Pound Toll' was introduced, and in 1793, it is recorded as being a penny per ton. The first lock house was not built until 1813; the occupier was Lock Keeper Thomas Hooney, who died in 1815. This man also had control of the two river ferries, and his successor, his son William, was quickly unable to cope. After much discussion, William was instructed to get help with the ferry services and confine himself to the lock. This man was never far from scandal and, by 1819, with his account keeping in question, William was replaced. By 1843, the lock's infrastructure had deteriorated, and its position also made navigation into it very difficult in high waters. Plans were drawn up (but never executed) to move the lock to the left bank of the Thames. Competition from the railways to transport goods affected river trade, and by 1854 (when William Wyatt was Lock Keeper), wages had been reduced. A new improved timber built lock was opened in September 1886. Marsh Lock is still in operation, coping admirably with the heavy flow of those who use the river for leisure pursuits.

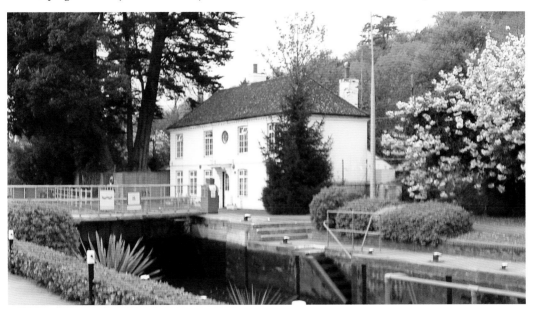

## Oxfordshire at War Through Time
### Stanley C. Jenkins

This fascinating selection of photographs traces some of the many
ways in which Oxfordshire changed during the war years.

978-1-4456-1946-0

96 pages, full colour

Available from all good bookshops or order direct
from our website www.amberleybooks.com